ALFRED MAURER: THE FIRST AMERICAN MODERN

EXHIBITION AND CATALOGUE ORGANIZED BY THE FREDERICK R. WEISMAN ART MUSEUM

ESSAY BY DAPHNE ANDERSON DEEDS

UNIVERSITY OF MINNESOTA

DISTRIBUTED BY UNIVERSITY OF MINNESOTA PRESS

MINNEAPOLIS AND LONDON

PUBLISHED BY:
Frederick R. Weisman Art Museum
University of Minnesota
333 East River Road
Minneapolis, MN 55455
Phone: 612-625-9494
www.weisman.umn.edu

DISTRIBUTED BY:
The University of Minnesota Press
111 Third Avenue South, Suite 290
Minneapolis, MN 55401
www.upress.umn.edu

FRONT COVER: **HEAD OF A GIRL**, *1929* (CAT. NO. 50)
BACK COVER: **YELLOW PEAR AND ROLL**, *circa 1920* (CAT. NO. 16)

DESIGNERS: Graphic Design for Love (+$), St. Paul
EDITORS: Phil Freshman and Susan C. Jones, Minneapolis
PRINTER: Print Craft, Inc., St. Paul

ISBN: 0-8166-4382-2

A Cataloging-in-Publication record for this book is available from the
Library of Congress.

EXHIBITION ITINERARY

GEORGIA MUSEUM OF ART, UNIVERSITY OF GEORGIA, ATHENS
APRIL 5–JUNE 15, 2003

THE MARION KOOGLER McNAY ART MUSEUM, SAN ANTONIO, TEXAS
JULY 15–SEPTEMBER 21, 2003

PALMER MUSEUM OF ART, THE PENNSYLVANIA STATE UNIVERSITY, UNIVERSITY PARK
OCTOBER 7–DECEMBER 21, 2003

GREENVILLE COUNTY MUSEUM OF ART, GREENVILLE, SOUTH CAROLINA
FEBRUARY 4–APRIL 10, 2004

WESTMORELAND MUSEUM OF AMERICAN ART, GREENSBURG, PENNSYLVANIA
AUGUST 8–OCTOBER 17, 2004

FREDERICK R. WEISMAN ART MUSEUM, UNIVERSITY OF MINNESOTA, MINNEAPOLIS
SEPTEMBER 3–DECEMBER 31, 2005

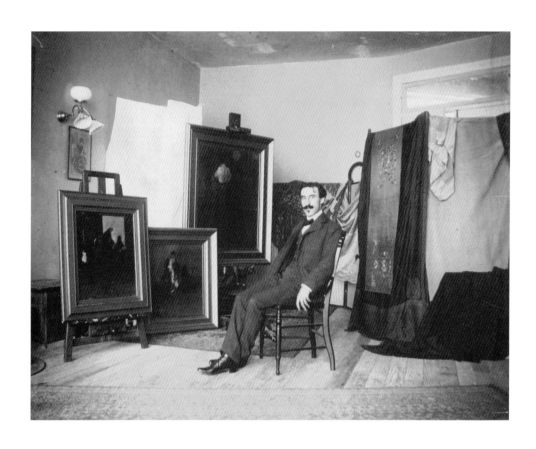

Maurer in his Paris studio, circa 1900. His painting *Copying in the Louvre*
(Hirshhorn Museum and Sculpture Garden, Smithsonian Institution,
Washington, D.C.) is displayed at far left. Private collection.

CONTENTS

ACKNOWLEDGMENTS

I want to acknowledge the National Endowment for the Arts for its support in the conservation and preservation of Alfred Maurer's works. The Frederick R. Weisman Art Museum and this exhibition are beneficiaries of Emily Abbott Nordfeldt, who established the B. J. O. Nordfeldt Fund for American Art as a bequest to honor the Swedish-American painter who was her husband. Many thanks go to former Weisman Art Museum Curator Patricia McDonnell, who with me conceived this exhibition and selected most of the works included in it. Former Assistant Curator Kathleen Motes Bennewitz chose many of the drawings and provided much needed support during the project's early stages. Daphne Anderson Deeds wrote this book's engaging and insightful essay. Also, through her close examination of Maurer's works, she established date information for many of the pieces in the exhibition. The most special thanks go to Theresa Downing Davis and Jackie Starbird in our curatorial department. They assumed responsibility for the catalogue and exhibition tour and made everything happen professionally. Everyone in the museum world knows that a major exhibition and publication do not happen without the coordination of innumerable details. Theresa and Jackie did all that and more.

I also want to thank the following people for their efforts on this project: editing, Phil Freshman and Susan C. Jones; design, Kali Nikitas and Rich Shelton; artwork frames, William Adair and Jennifer Janicki of Gold Leaf Studios, Sandy Stewart of Nash Frame Design, Tamer Azzazi, and Patti Landres; framing and crating, Steve Ecklund, Mark Kramer, John Sonderegger, Holly Streekstra, Jane Weis, and Tim White; exhibition logistics, Karen Duncan and Laura Muessig; photography, Robert Fogt; conservation, Elizabeth Buschor and Jim Horns; and printing, Dick Schaehrer.

In the end, the museum is grateful to Hudson and Ione Walker, to Hudson's sister, Louise Walker McCannel, and her husband, Malcolm, and to Hudson and Ione's daughters, Berta, Harriet, and Louise, who have over the years supported their father's staunch belief in American artists and in the University of Minnesota. It is to the Walker family that I dedicate this catalogue.

LYNDEL KING
DIRECTOR AND CHIEF CURATOR

More than a decade ago, Frederick R. Weisman Art Museum Director Lyndel King, former Curator Patricia McDonnell, and I first contemplated the potential of an exhibition focusing on works by Alfred Maurer in the Weisman collection. Today, I am grateful to Lyndel and Patricia for entrusting me to contribute an essay about "the first American modern" and his art to the catalogue accompanying this important traveling exhibition.

Weisman Special Projects Coordinator Theresa Downing Davis facilitated my efforts with diligence and good spirits. I am also grateful to Curatorial Assistant Jackie Starbird for her resourceful search for reproductions and to Collections Manager John Sonderegger for his patience while I examined Maurer's works. Phil Freshman and Susan C. Jones lent their astute editorial abilities to the manuscript. And at the Walker Art Center, Minneapolis, I am indebted to Jill Vetter, the consummate archivist, who enabled me to uncover materials I would not otherwise have found. It has been a great pleasure to join these admirable professionals in recognizing the artistic contributions of Alfred Maurer.

DAPHNE ANDERSON DEEDS
SIMSBURY, CONNECTICUT
FEBRUARY 2003

FOREWORD

LYNDEL KING

Hudson D. Walker's substantial gift of art by Alfred Maurer to the Frederick R. Weisman Art Museum has enabled us to be the home of the largest public collection of that artist's work anywhere. The important collection of American art Walker formed with his wife, Ione, was loaned to the museum in the early 1950s; over the years, some of these works were presented as gifts, and the rest came as a bequest when Hudson Walker died in 1976. In addition to the Maurer paintings and works on paper, the Walker gifts and bequest included a large group of artworks by Marsden Hartley as well as pieces by Milton Avery, Oscar Bluemner, Arthur B. Carles, Arthur Dove, Walt Kuhn, Jacob Lawrence, Ernest Lawson, Stanton Macdonald-Wright, Guy Pène du Bois, John Sloan, Raphael Soyer, Abraham Walkowitz, Max Weber, Marguerite Zorach, and other Americans who were active in the first half of the twentieth century. All but one of the works included in this exhibition and catalogue were gifts of Hudson and Ione Walker or were part of Hudson Walker's bequest. Elva Walker Spillane, who died in 2001, made a generous bequest of Maurer's exquisite *Two Heads* (1928–30, CAT. NO. 49, PP. 62, 63), which we are also pleased to feature.

Hudson Walker was born in 1907 into a family that played a key role in the history of Minnesota's lumber industry and its art museums. His paternal grandfather, Thomas Barlow Walker, had vast lumber holdings in Minnesota, California, and Nevada. He also profited from real estate with ventures that included development of the major Minneapolis suburb of St. Louis Park. By 1923 he was, according to the *New York Times*, one of the nation's ten richest men.

Over the years, T. B. Walker assembled a considerable collection of paintings and sculptures, focusing on landscapes, portraits, and historically themed paintings by American and European artists. He built a skylit exhibition space alongside his downtown Minneapolis mansion and opened it, in 1879, as the state's first public art gallery. He subsequently expanded the gallery, then moved it to the city's Lowry Hill neighborhood. In 1939, twelve years after his death, it was reorganized as the Walker Art Center, which became an internationally renowned museum showcasing modern and contemporary art. Besides exhibiting his own collection, T. B. Walker in 1883 was a co-founder, with twenty-four other local leaders, of the Minneapolis Society of Fine Arts. That organization became the Minneapolis Institute of Arts, Minnesota's largest museum, which opened in 1914.

Hudson Walker and his sister, Louise Walker McCannel, were always more interested in the family's avocation of art collecting than they were in lumber and real estate. Hudson attended the University of Minnesota from 1925 to 1928 and then enrolled in Paul Sachs's famous museum course at Harvard's Fogg Art Museum. This course, which Sachs started in 1921 and led for twenty-five years, produced curators and directors of America's leading museums and must have been a heady experience for the young Minnesotan. After Harvard, Walker opened an art gallery in Boston.

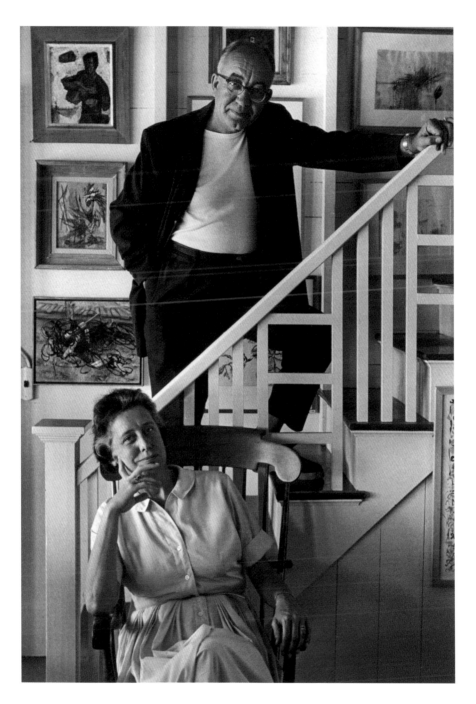

Arnold Newman (American, b. 1918)
Ione and Hudson Walker, 1964
gelatin silver print

© Arnold Newman/Getty Images

He returned to Minnesota in 1932 and two years later was asked by University of Minnesota President Lotus Coffman to establish an art gallery for the university. It was first called the Little Gallery, then the University Gallery, and later the University Art Museum. In 1993 it moved into permanent quarters in a remarkable building, designed by Frank Gehry, and was renamed the Frederick R. Weisman Art Museum after a major donor to the new facility.

In 1934 Coffman wrote idealistically about the need for "new values to sustain the morale of individuals in the days ahead." The arts, he asserted, "are a source for such values, and I want this University to play a leading part in instilling them." It was natural that Coffman turned to the Harvard-trained son of a leading Minneapolis art-collecting family to help with this enterprise. Walker eagerly accepted the challenge, putting his art-world contacts and some of his family's money to use in the program. To Coffman's notion that the museum should provide students — and all citizens of the state — with daily access to works of art, Walker added the idea that the university should acquire an art collection to be used as an aid to teaching. He wrote that a university museum should emphasize "a workshop character . . . as against most people's notion of a museum as a place for [the] safekeeping of rare objects."

When he left his position as first curator (and only staff member) of the university's gallery in 1936, Walker advised Coffman not to try to form a general art collection, suggesting instead a focus on American art. At the time there was nowhere else in the Twin Cities to see important American art and international contemporary work. The Walker gallery was then still showing T. B. Walker's eclectic collection of mostly European art, and the Minneapolis Institute of Arts was not interested in brash young American artists.

The same year he left the university, Hudson Walker moved to New York to open a commercial venue on East Fifty-seventh Street, then the center of the city's contemporary art gallery scene. Devoted to the promotion of living artists, he was a sensitive and sympathetic dealer who became personally concerned with the daily tribulations of artists associated with his gallery. Walker did not represent Alfred Maurer and never met him; the artist had committed suicide in 1932. But William Waltemath, an artist Walker represented and the last person to have seen Maurer alive, persuaded him to handle Maurer's estate for Eugenia Maurer Fuerstenberg, Maurer's sister. He tried unsuccessfully to get Duncan Phillips to acquire the estate for the Phillips Collection in Washington, D.C., and eventually purchased it himself, reportedly for $1,500. He later was ancillary executor of the estate of Marsden Hartley, which he also acquired.

In 1950, ten years after closing his New York gallery and in the spirit of the recommendations he had made to Lotus Coffman in the mid-1930s, Walker put his collection "at the service of the University" of Minnesota through a long-term loan of more than a thousand works of art. He wrote to then President James Lewis Morrill that this "series of American paintings, particularly those by Hartley and Maurer, would be the backbone of a collection to show the development of American art between 1893 and 1943. . . . Those two artists neatly summarize most of the stylistic developments of those years." By 1953 Walker had given the museum more than three hundred works of art, including several Maurer paintings. As noted, Walker and his wife, Ione, made intermittent gifts to the museum until his death. His bequest included some twelve hundred works of art. The museum now owns 644 works by Alfred Maurer, gifts and bequests of Hudson and Ione and other members of the Walker family.

In 1949 Hudson Walker helped organize a retrospective exhibition of Maurer's work at the Walker Art Center that went to the Whitney Museum of American Art in New York and then toured nationally. He also arranged for the art historian Elizabeth McCausland to write a biography of the artist that was published in 1951. However, Maurer remained largely unrecognized by major museums until 1973, when a retrospective exhibition was organized at the National Collection of Fine Arts (today the Smithsonian American Art Museum) in Washington, D.C. That show, appearing at the start of what has become a sustained historical reevaluation of American art, may have occurred too early to establish his reputation. Over the past several decades, various scholars have taken to calling Maurer the first American modern—the first to demonstrate what it meant to be a modern artist in this country in the early decades of the twentieth century. The present exhibition shows his painterly virtuosity and psychological complexity and may come at a time when viewers are receptive to recognizing his contributions. We hope that the exhibition and book together become part of a reconsideration of Alfred Maurer's position in American art history and help foster a new appreciation of his talent by scholars and museum visitors alike.

Plates

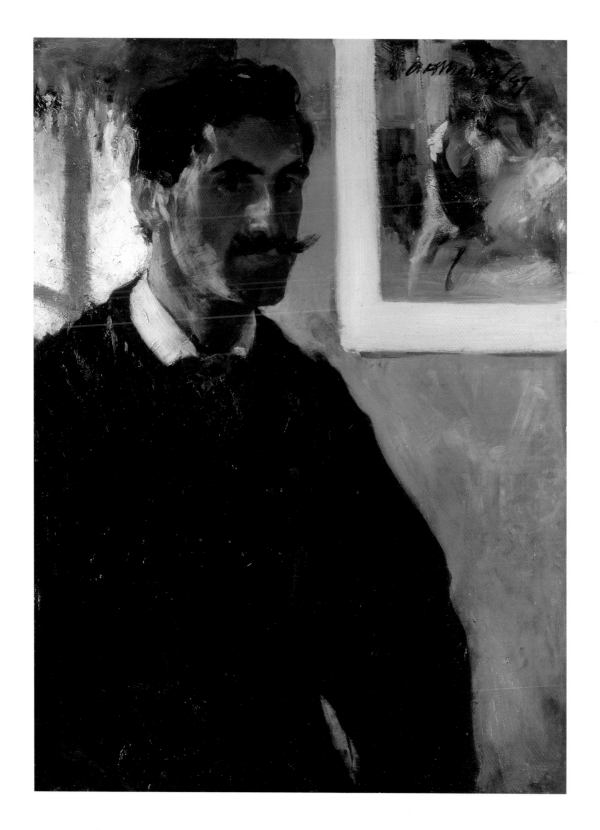

SELF-PORTRAIT, *1897*
OIL ON CANVAS (CAT. NO. 2)

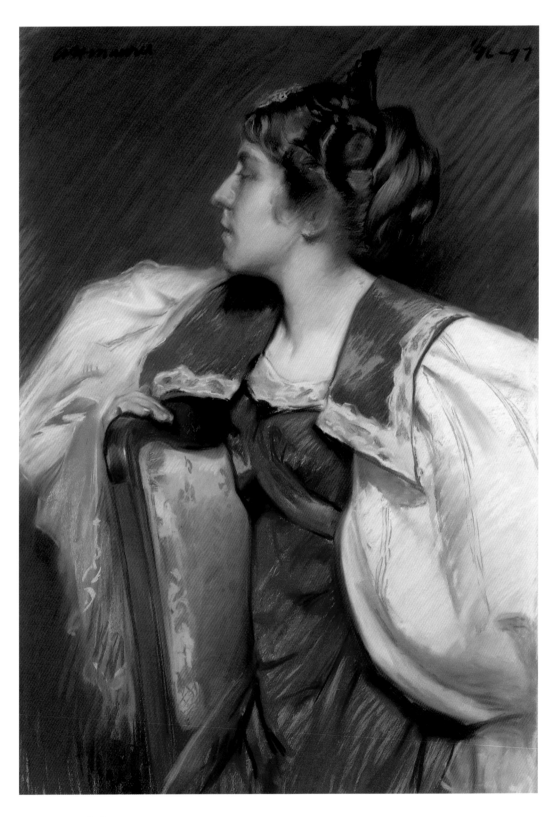

EUGENIA MAURER, *1896–97*
PASTEL ON PAPER ON FABRIC (CAT. NO. 1)

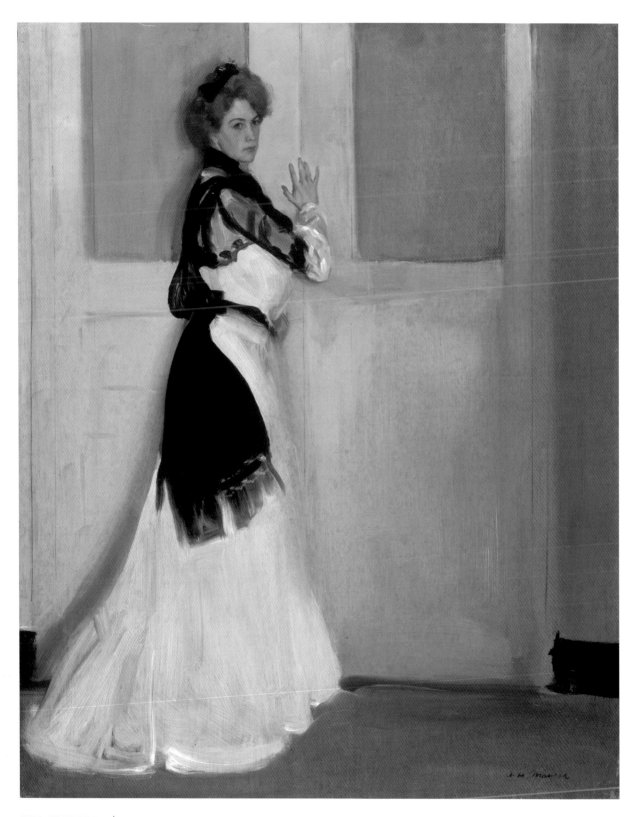

GIRL IN WHITE, *circa 1901*
OIL ON WOOD PANEL (CAT. NO. 3)

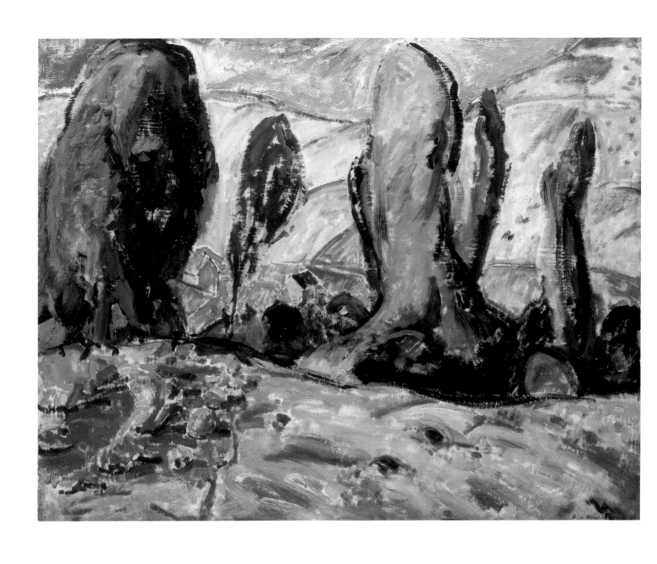

LANDSCAPE (AUTUMN), *1909*
OIL ON CANVAS (CAT. NO. 4)

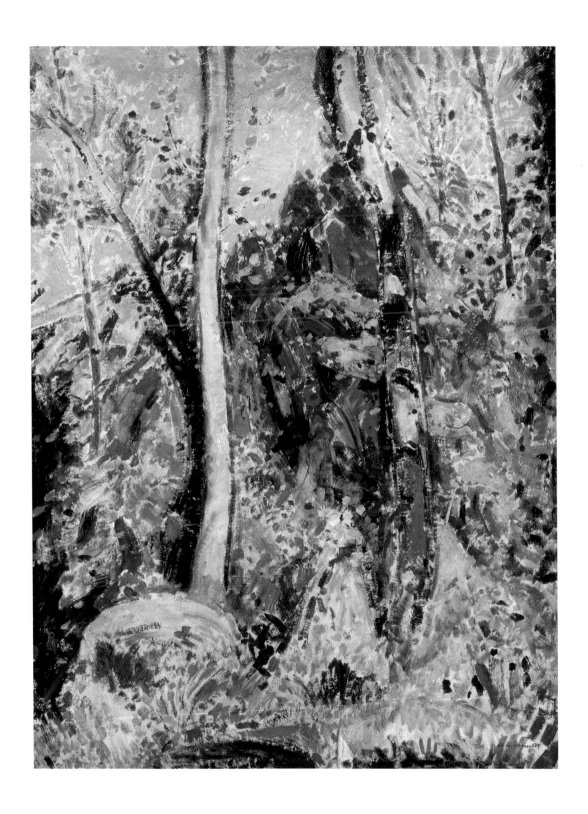

LANDSCAPE WITH TREES, *1909*
OIL ON COMPOSITION BOARD (CAT. NO. 5)

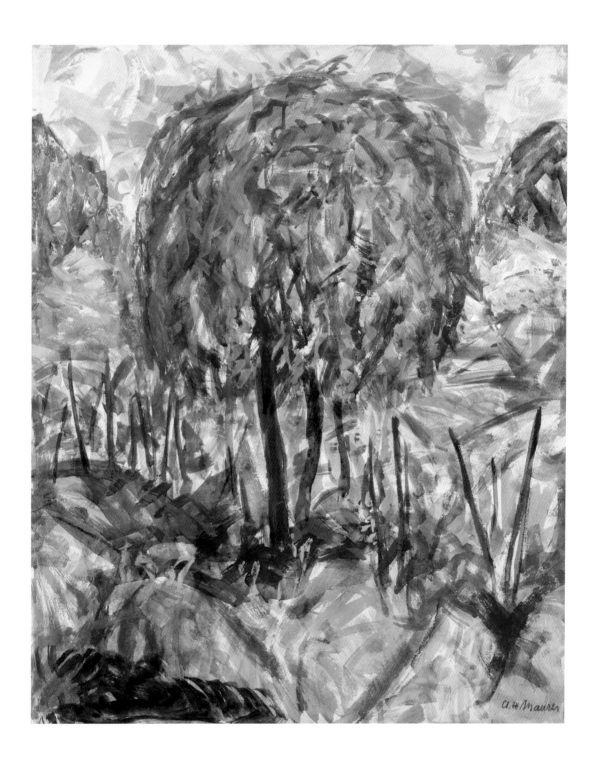

LANDSCAPE, *circa 1915–24*
WATERCOLOR AND GOUACHE ON PAPER (CAT. NO. 6)

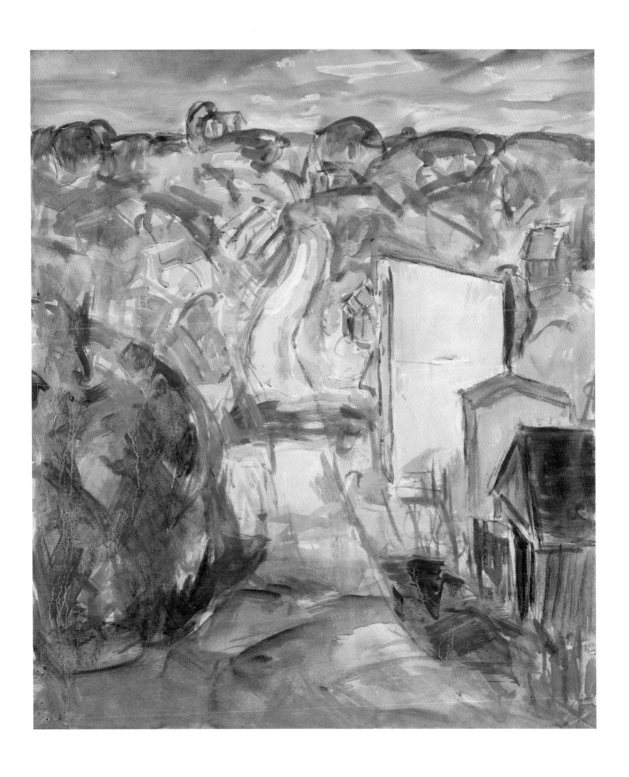

LANDSCAPE, *circa 1915–24*
WATERCOLOR, GOUACHE, AND CHALK ON PAPER (CAT. NO. 7)

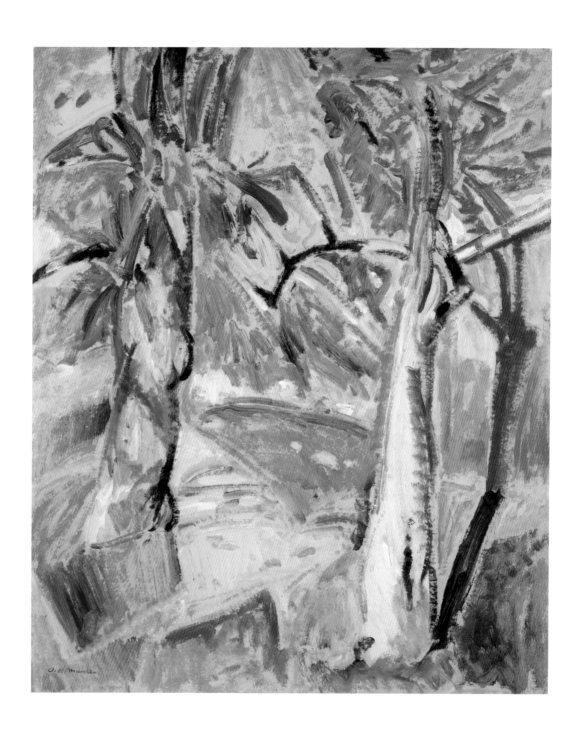

LANDSCAPE, *1916*
OIL ON PAPER ON CARDBOARD (CAT. NO. 8)

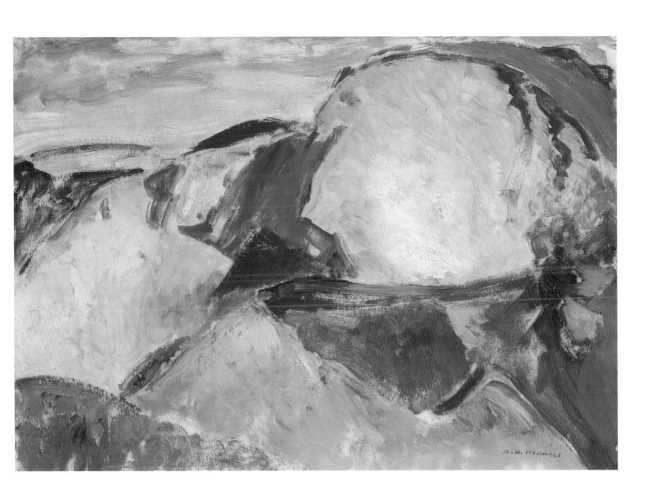

LANDSCAPE, *1916–18*
OIL ON PAPER (CAT. NO. 9)

top: **LANDSCAPE,** *n.d.*
CONTÉ CRAYON ON PAPER (CAT. NO. 10)

bottom: **LANDSCAPE,** *n.d.*
CONTÉ CRAYON ON PAPER (CAT. NO. 11)

top: **LANDSCAPE,** *n.d.*
CONTÉ CRAYON ON PAPER (CAT. NO. 12)

bottom: **LANDSCAPE,** *n.d.*
CONTÉ CRAYON ON PAPER (CAT. NO. 13)

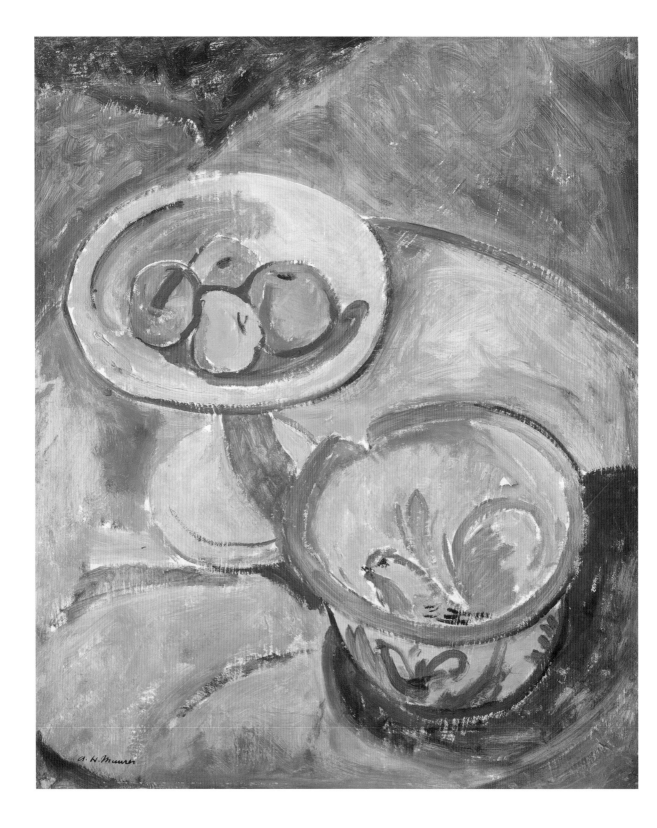

STILL LIFE, *circa 1908*
TEMPERA ON CARDBOARD (CAT. NO. 14)

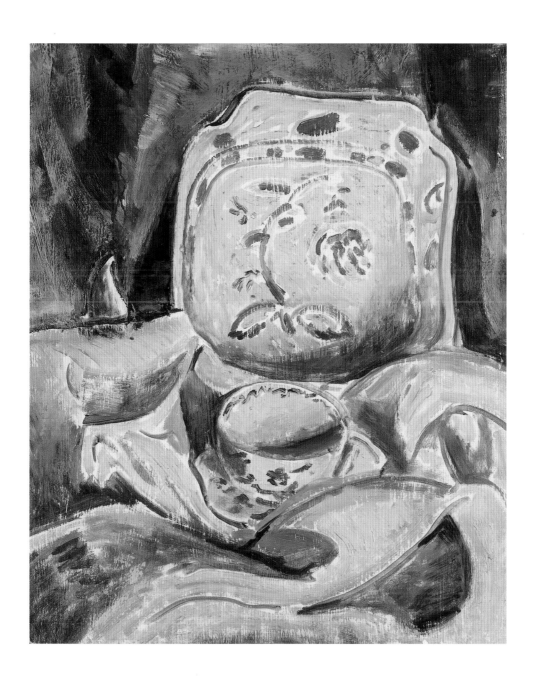

STILL LIFE, *circa 1910*
OIL ON CARDBOARD (CAT. NO. 15)

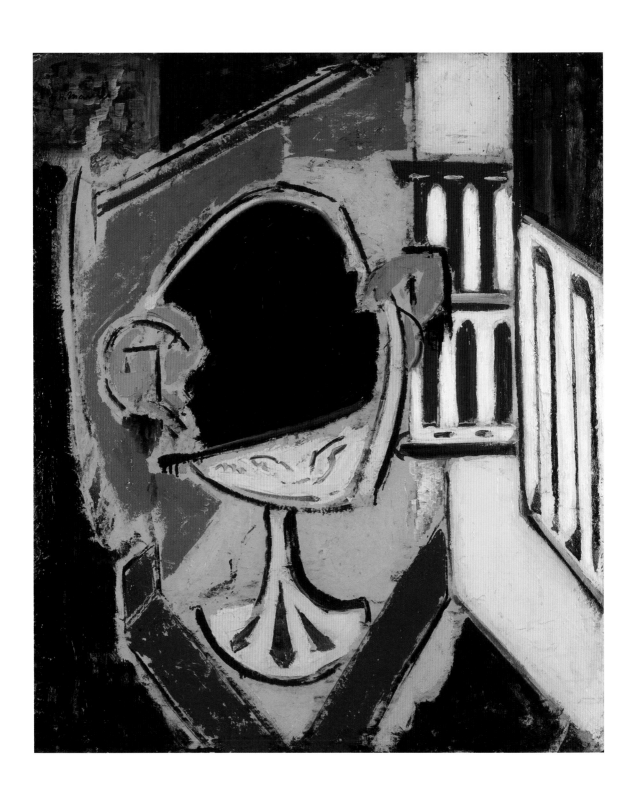

BRASS BOWL, *1927–28*
OIL ON COMPOSITION BOARD (CAT. NO. 17)

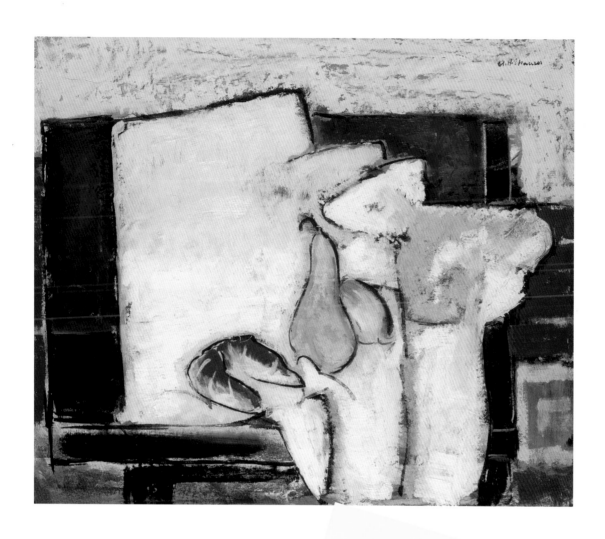

YELLOW PEAR AND ROLL, *circa 1920*
OIL ON COMPOSITION BOARD (CAT. NO. 16)

ABSTRACT STILL LIFE, NO. 2, *1928–30*
GOUACHE ON CARDBOARD (CAT. NO. 18)

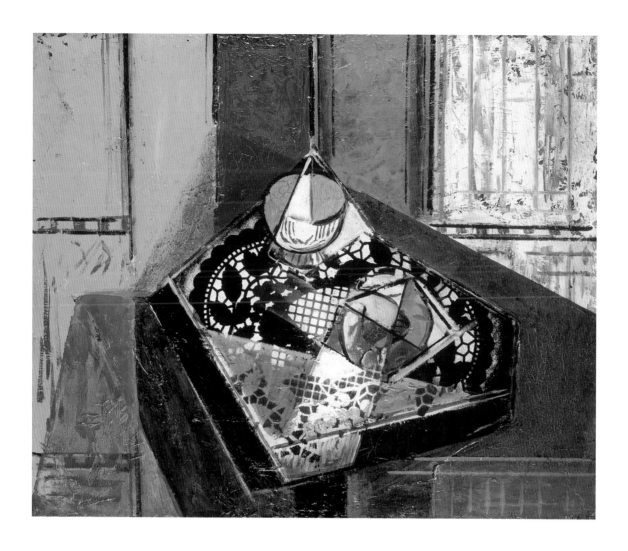

STILL LIFE WITH CUP, *circa 1929*
OIL ON COMPOSITION BOARD (CAT. NO. 19)

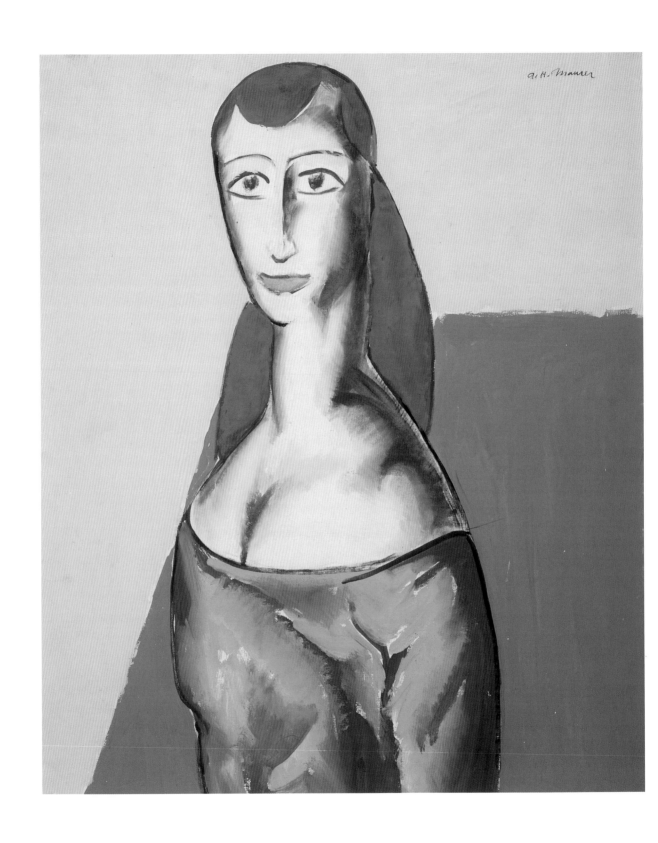

GIRL, *circa 1923*
GOUACHE ON PAPER (CAT. NO. 21)

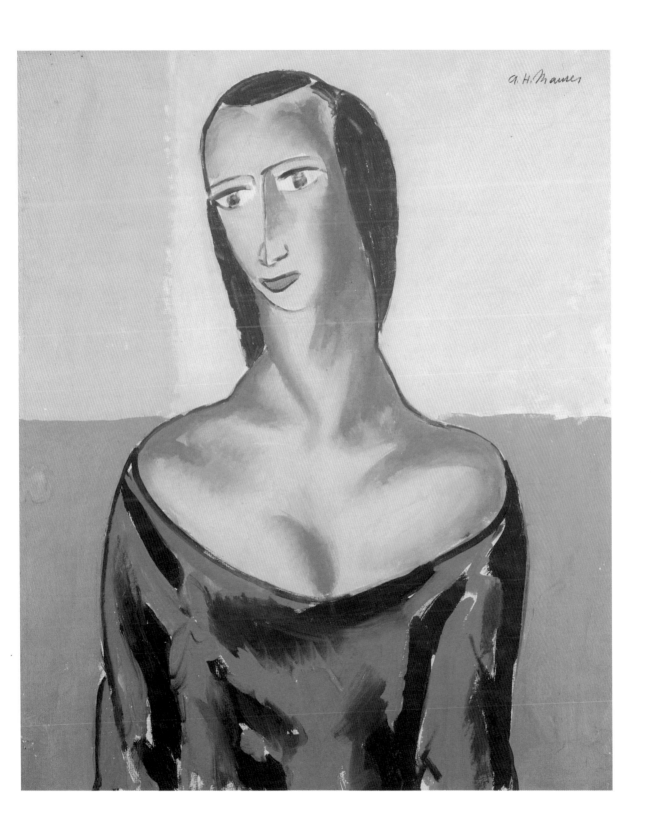

GIRL, *circa 1923*
GOUACHE ON PAPER (CAT. NO. 20)

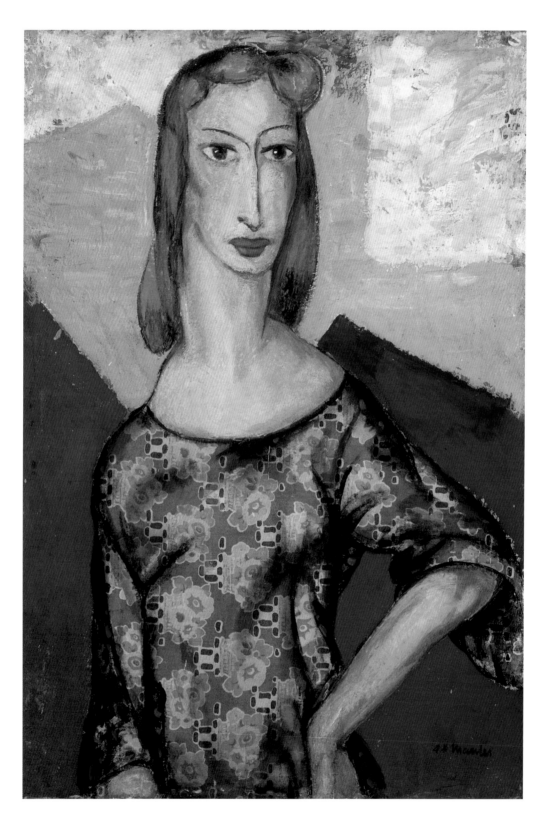

PORTRAIT OF A GIRL IN A FLOWERED DRESS, *1924*
CASEIN ON FIGURED FABRIC ON COMPOSITION BOARD (CAT. NO. 22)

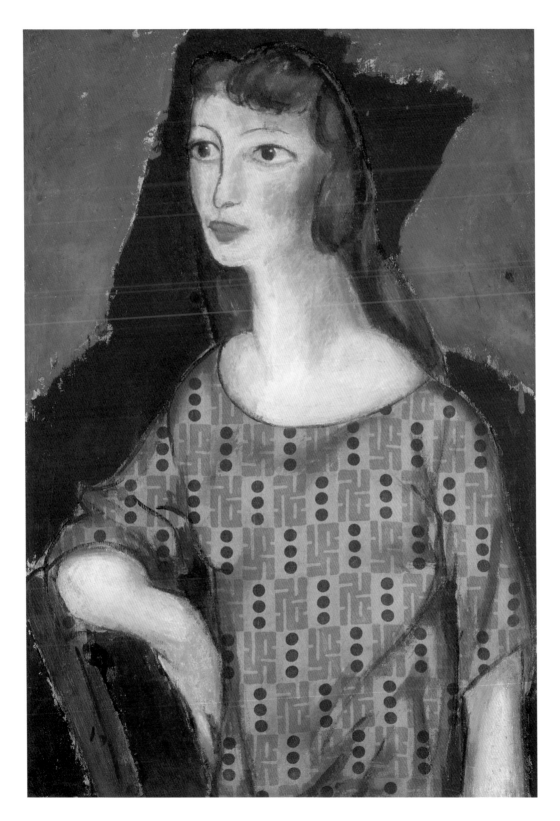

PORTRAIT OF A GIRL, *1924*
CASEIN ON FIGURED FABRIC ON CARDBOARD (CAT. NO. 23)

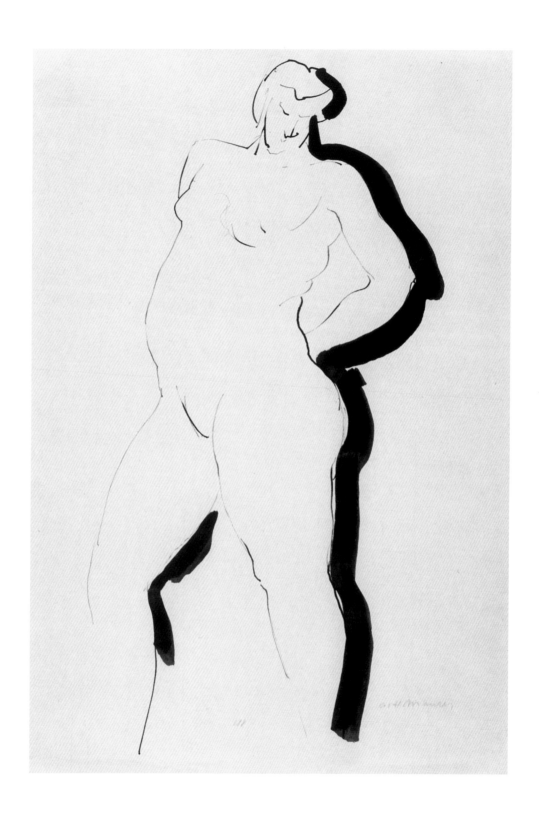

NUDE, *circa 1927–28*
INK AND WASH ON PAPER (CAT. NO. 40)

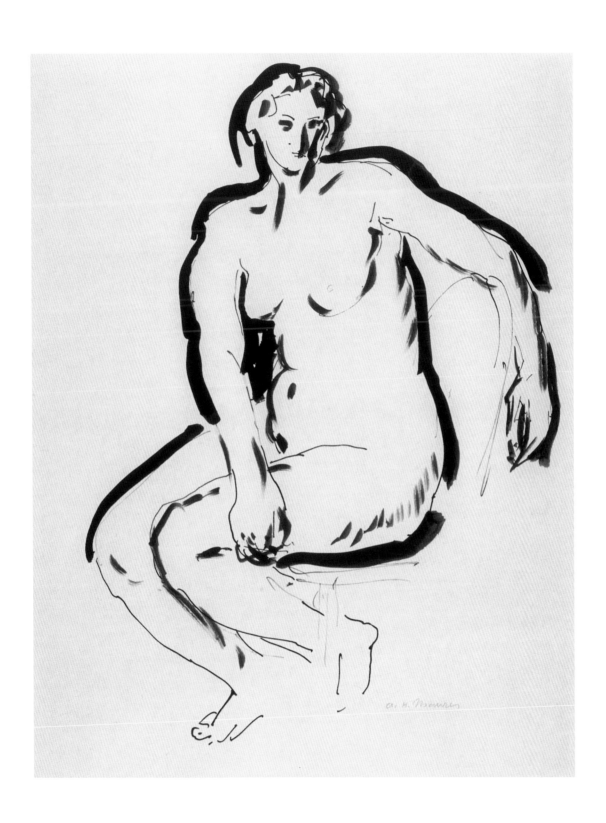

SEATED FIGURE, *circa 1927–28*
INK AND WASH ON PAPER (CAT. NO. 45)

FEMALE NUDE, *circa 1927–28*
GRAPHITE ON PAPER (CAT. NO. 34)

NUDE, *circa 1927–28*
GRAPHITE ON PAPER (CAT. NO. 41)

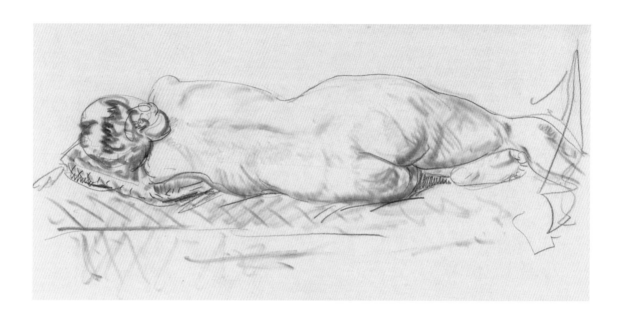

RECLINING FIGURE, *n.d.*
GRAPHITE AND CHARCOAL ON PAPER (CAT. NO. 47)

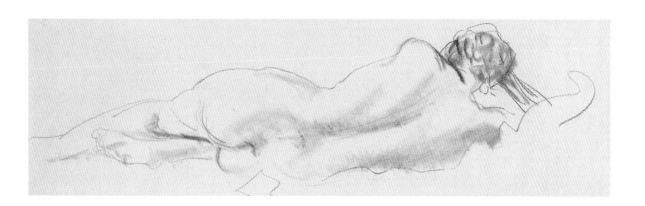

RECLINING FIGURE, *circa 1927–28*
GRAPHITE AND CHARCOAL ON PAPER (CAT. NO. 46)

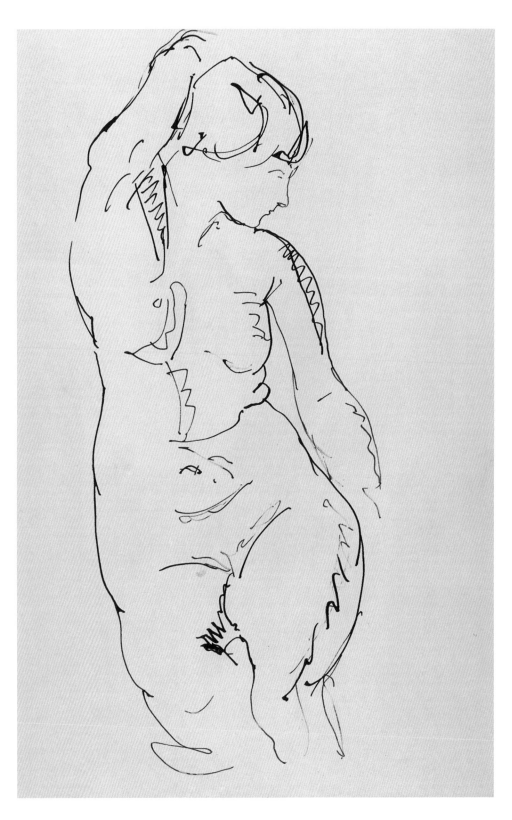

FEMALE NUDE WITH RAISED ARM, *circa 1927–28*

INK ON PAPER (CAT. NO. 35)

BENDING FIGURE, *circa 1927–28*
CONTÉ CRAYON ON PAPER (CAT. NO. 33)

43

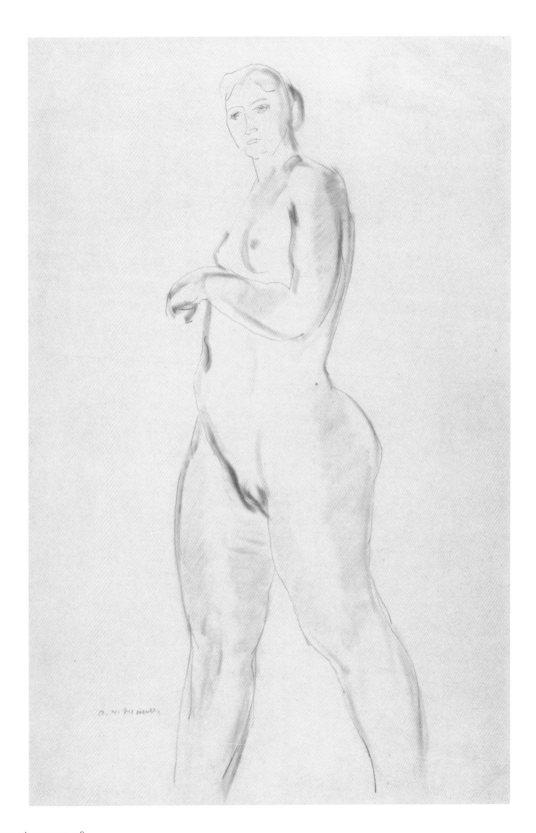

FIGURE, *circa 1927–28*
GRAPHITE ON PAPER (CAT. NO. 36)

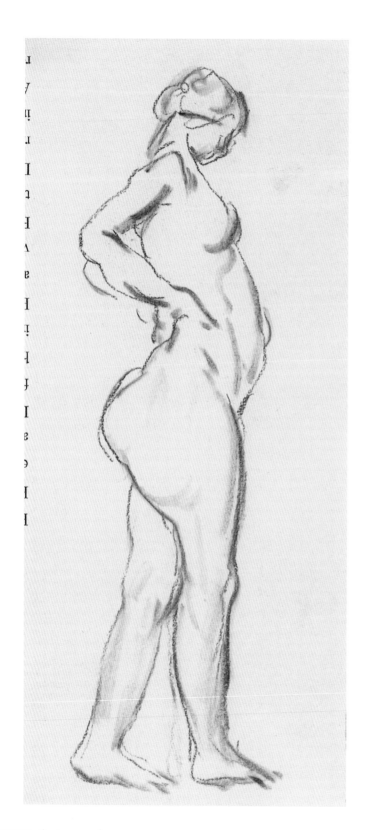

FIGURE, *circa 1927–28*
CONTÉ CRAYON ON PAPER (CAT. NO. 38)

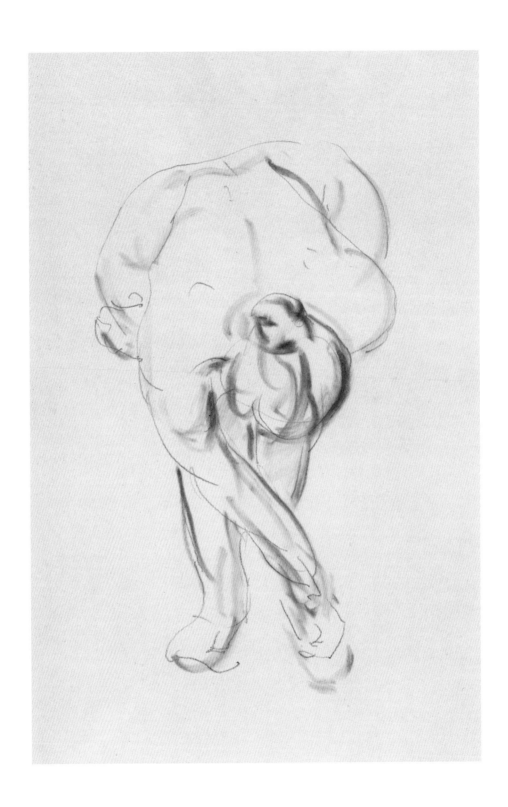

BENDING FIGURE, *circa 1927–28*
GRAPHITE ON PAPER (CAT. NO. 32)

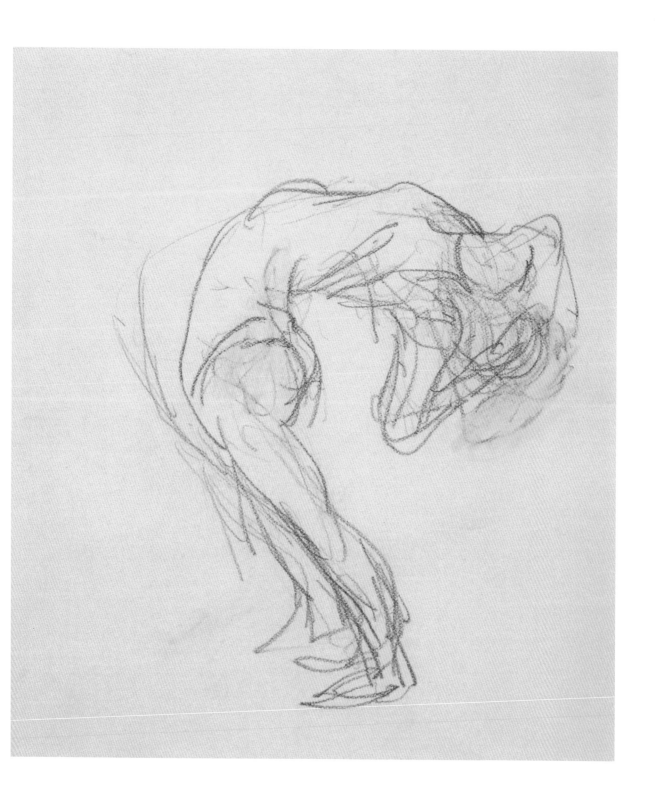

NUDE DOING BACKBEND, *circa 1927–28*
GRAPHITE ON PAPER (CAT. NO. 43)

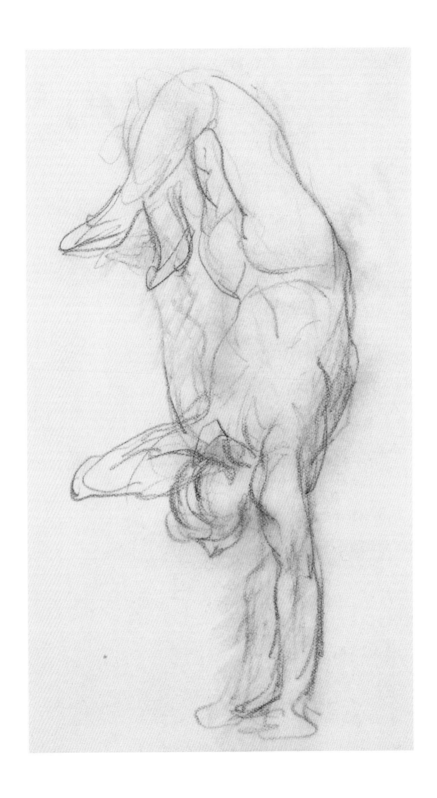

NUDE DOING HANDSTAND, *circa 1927–28*
GRAPHITE ON PAPER (CAT. NO. 44)

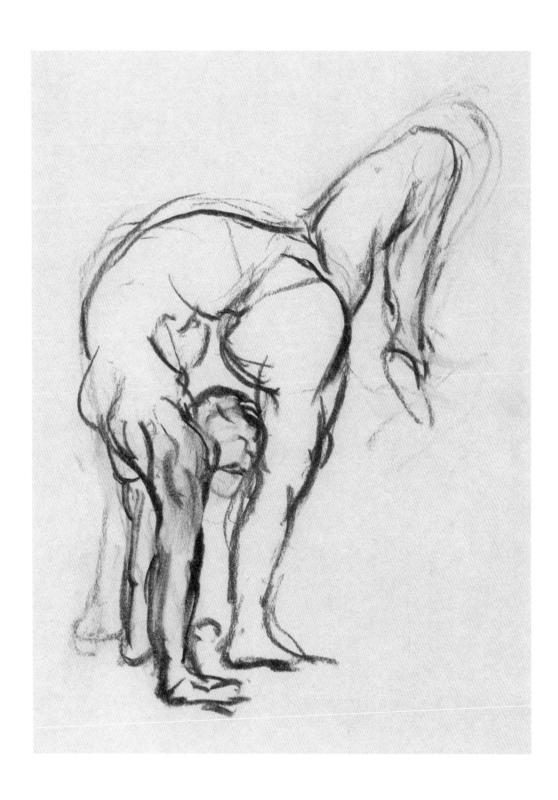

NUDE DOING BACKBEND, *circa 1927–28*
CHARCOAL ON PAPER (CAT. NO. 42)

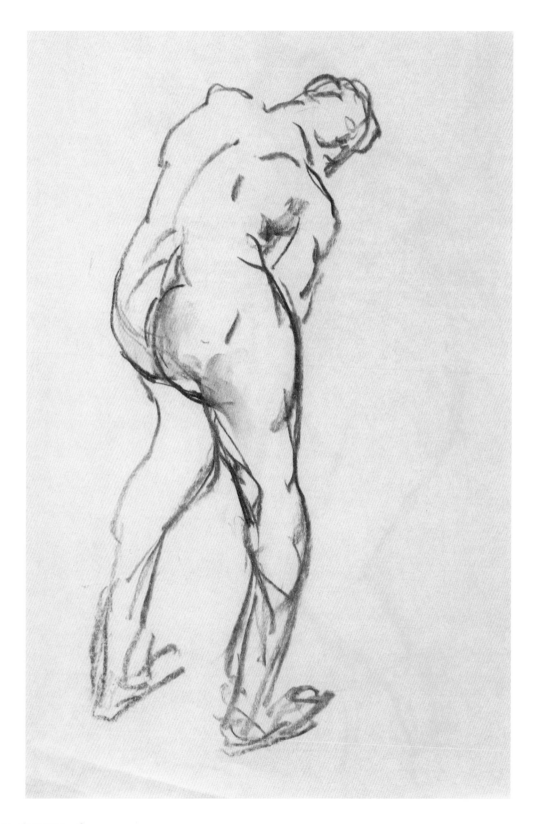

FIGURE, *circa 1927–28*
CONTÉ CRAYON ON PAPER (CAT. NO. 37)

FIGURE, *circa 1927–28*
CHARCOAL ON PAPER (CAT. NO. 39)

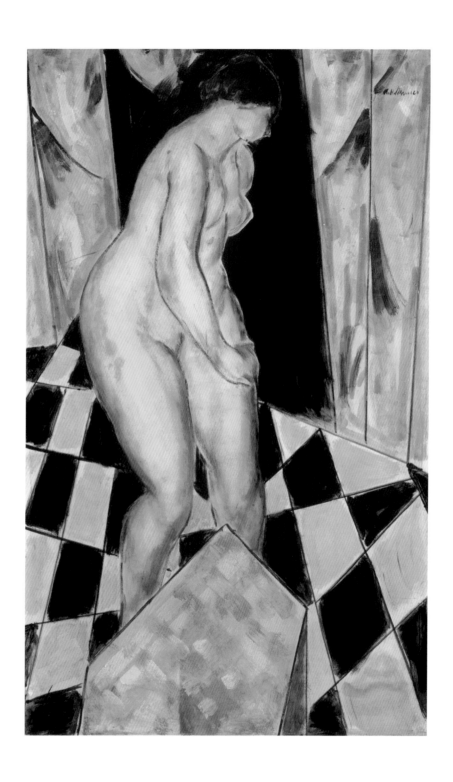

NUDE, *1927*
OIL ON COMPOSITION BOARD (CAT. NO. 24)

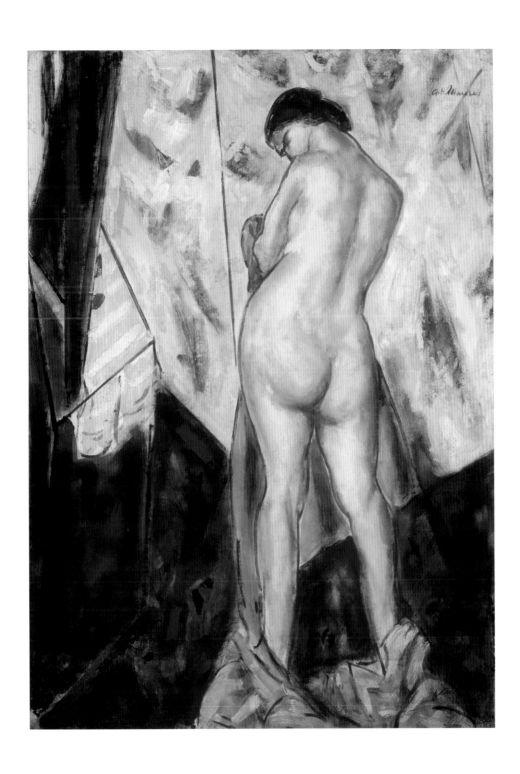

STANDING FEMALE NUDE, *1928*
OIL ON WOOD (CAT. NO. 31)

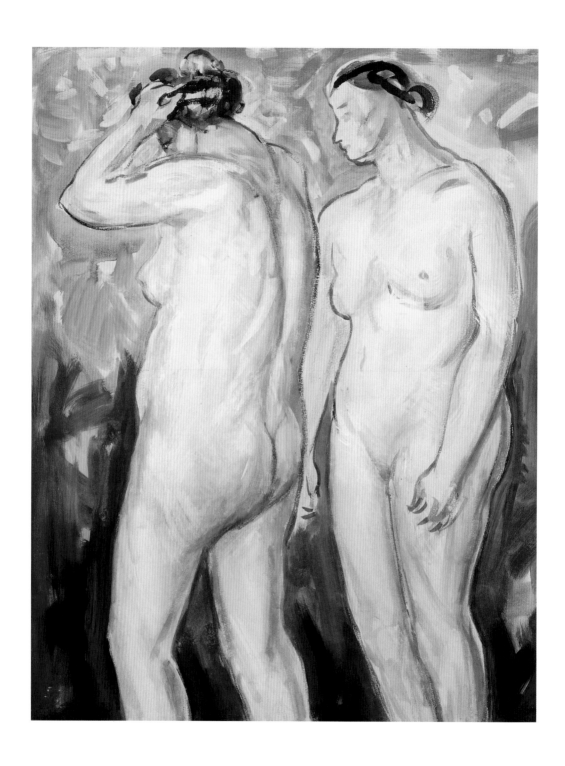

TWO FIGURES, *circa 1927–28*
GOUACHE AND WATERCOLOR ON PAPER (CAT. NO. 30)

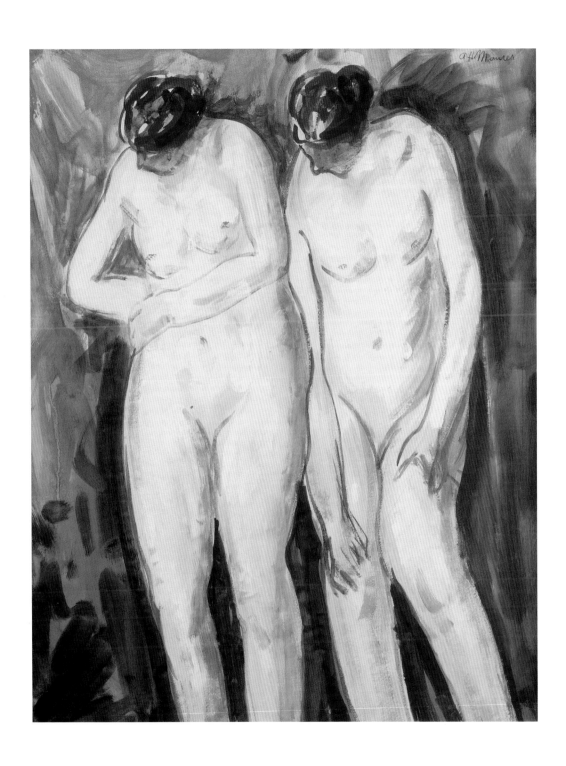

TWO FIGURES, *circa 1927–28*
GOUACHE AND WATERCOLOR ON PAPER (CAT. NO. 28)

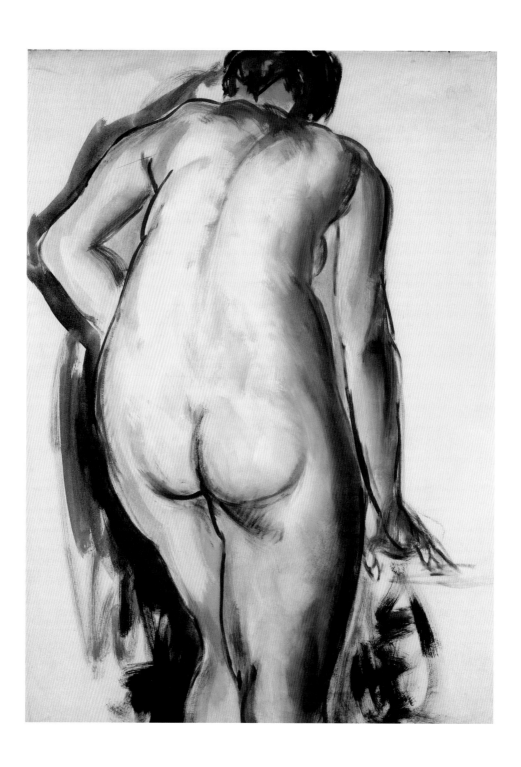

FIGURE, *circa 1927–28*
GOUACHE AND WATERCOLOR ON PAPER (CAT. NO. 29)

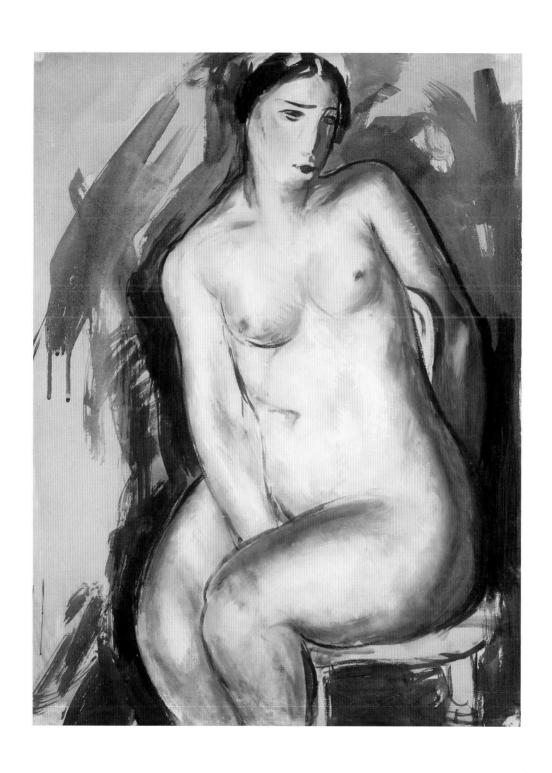

SEATED FIGURE, *circa 1927–28*
GOUACHE AND WATERCOLOR ON PAPER (CAT. NO. 27)

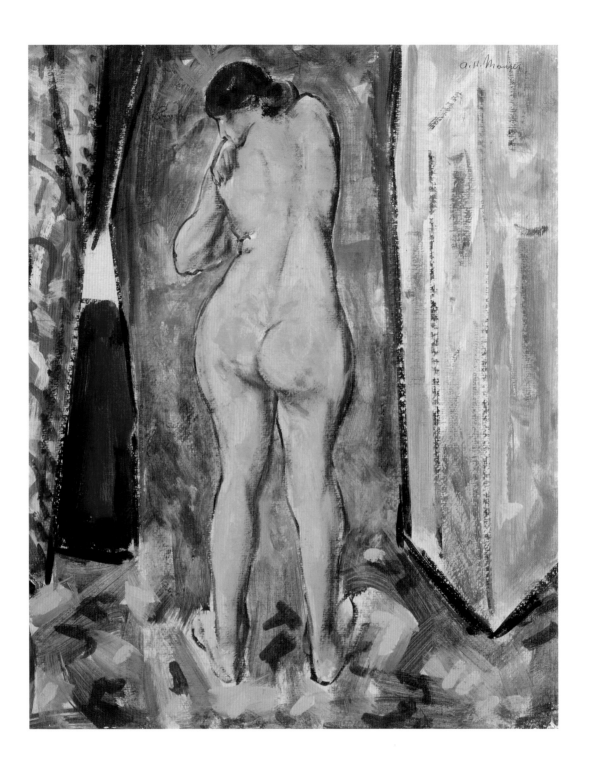

STANDING FEMALE NUDE, *1927–28*
CASEIN ON COMPOSITION BOARD (CAT. NO. 26)

CONTORTIONIST, *1927–28*
OIL ON COMPOSITION BOARD (CAT. NO. 25)

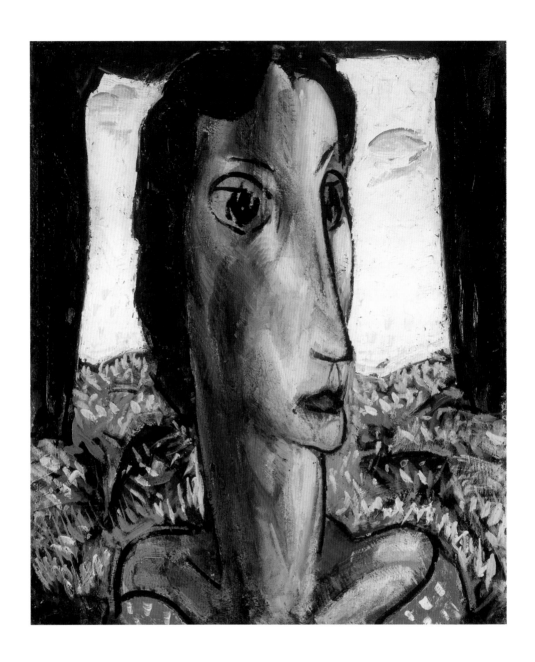

HEAD OF A GIRL, *1929*
OIL ON CLOTH ON COMPOSITION BOARD (CAT. NO. 50)

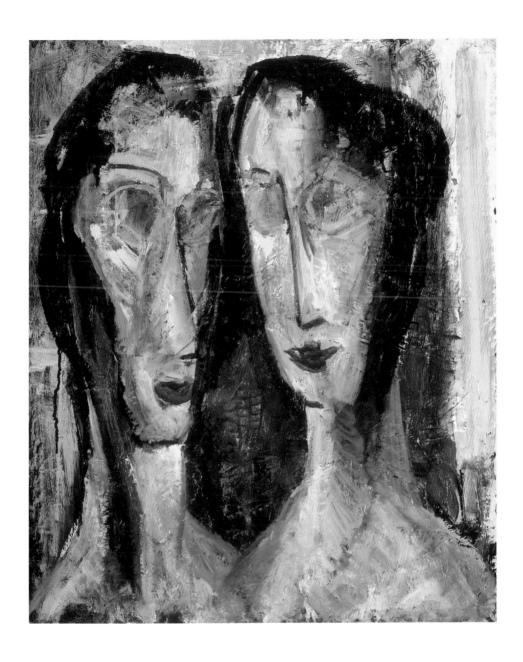

TWO HEADS WITH YELLOW BACKGROUND, *1928–29*
OIL ON COMPOSITION BOARD (CAT. NO. 48)

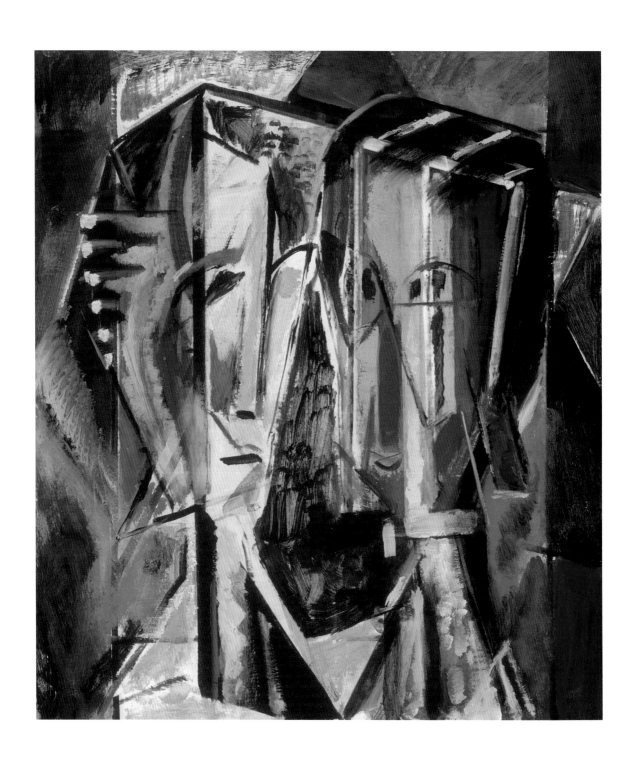

TWO HEADS, *1928–30* (front)
OIL ON CANVAS ON BOARD (CAT. NO. 49)

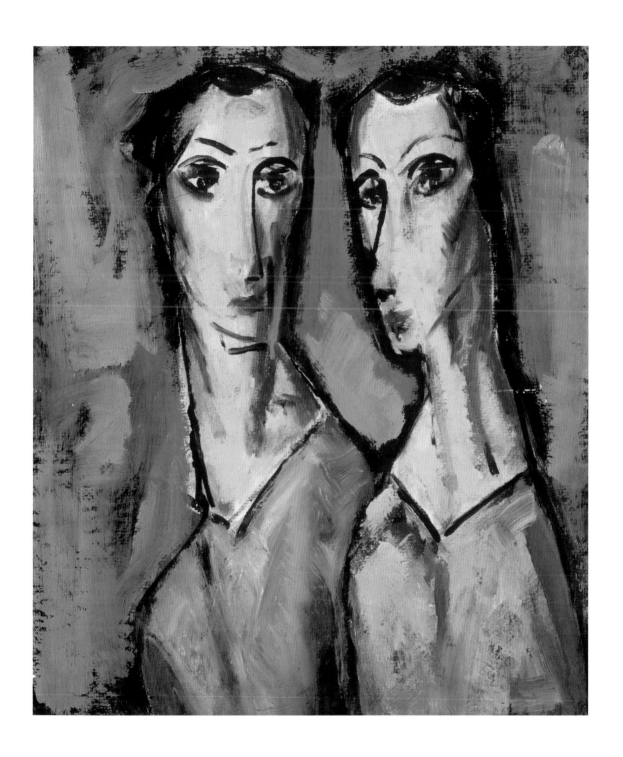

TWO HEADS, *1928–30* (back; not exhibited)
OIL ON CANVAS ON BOARD (CAT. NO. 49)

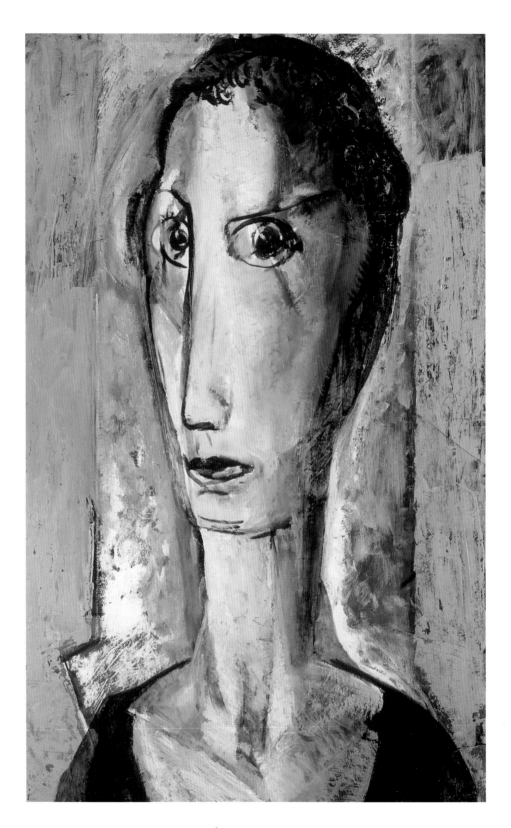

PORTRAIT OF A GIRL WITH GRAY BACKGROUND, *circa 1930*
OIL ON COMPOSITION BOARD (CAT. NO. 51)

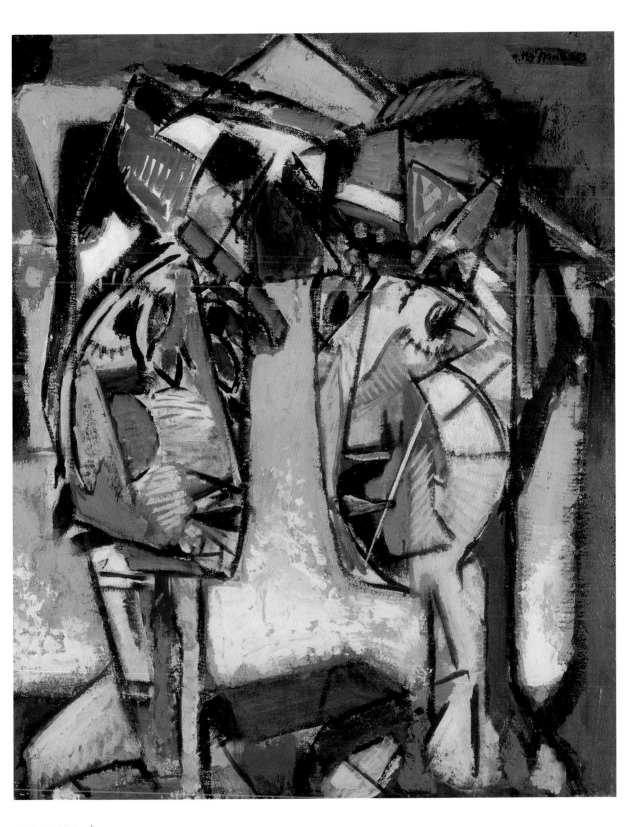

TWO HEADS, *circa 1930*
OIL ON COMPOSITION BOARD (CAT. NO. 52)

ALFRED MAURER: THE FIRST AMERICAN MODERN

DAPHNE ANDERSON DEEDS

Alfred Maurer was one of the most prolific and progressive artists of the early modern period in the United States. Often referred to as "the first American modern," he left a burgeoning career as an academic painter in New York City to live in Paris, where he enthusiastically embraced Henri Matisse's vision and almost singled-handedly imported fauvism to America. Maurer's complex career bridged virtually all the major stylistic developments of the early twentieth century: impressionism, postimpressionism, fauvism, cubism, and expressionism. Although he prospered during his early aesthetic phase, he soon eschewed convention and relentlessly challenged himself to pursue a personal expressionism that was both advanced and bewildering. In Maurer's work we can trace the trajectory from early modern experimentation to the introspection of abstract expressionism, the artistic movement that flourished more than a decade after his death. In spite of the singularity of his career, Maurer seldom attracted critical praise while he was alive. Even today, his name is secondary in the American artistic pantheon.

Why were this artist and his paintings overlooked? Some art historians attribute the desultory reaction to Maurer's work to his numerous stylistic changes, his lack of commercial representation, and a reactionary press.[1] Throughout his career, Maurer sought galleries to represent him, and he was included in numerous group exhibitions in the United States and abroad. Although he was not entirely ignored by the art press, mentions of him typically were brief. Consequently, his aspirations for critical acceptance were not realized during his lifetime. It was not until the mid-1930s and 1940s that critics and art historians began seriously assessing his contributions to modernism.

Perhaps Maurer's frequent stylistic shifts and seeming inability to work in a consistent pattern for a sustained period were what led viewers to dismiss his talent. The underlying reason Maurer was creatively unsettled may be found within the artist himself. His endless searching and experimenting with myriad methods and styles may in fact provide a key to the nature of this lonely and ultimately tragic figure.

Some art historians question the efficacy of biography when interpreting an artist's work, declaring that art should speak for itself and that personal details are extraneous. Others focus on information about the artist's life and personality, linking particular events and relationships to specific imagery and stylistic changes. Although I generally tend to rely on the formal indicators of art's meanings, in the case of Maurer I cannot avoid exploring the facts of his life. His personal history is inextricably bound to his work, and his often obscure career is rendered more coherent when we consider the experiences that may have motivated this peripatetic artist and his often tortured soul.

Alfred Henry Maurer (FIG. 1) was born in New York City on April 21, 1868, to German immigrant Karl Ludwig (known as Louis) Maurer and American Louisa Stein. He had an older brother, Charles, and a younger sister, Eugenia. Their mother was a dutiful wife and housekeeper whose self-effacing personality was overshadowed by that of her domineering husband. Louis Maurer had left high school to enter the field of commercial lithography, and ultimately he became a prominent illustrator for Currier and Ives (FIG. 2). In 1884 Louis insisted that his sixteen-year-old son leave New York's Public School 58 to join the family lithographic-printing ̶ ̶ ̶ ̶ ̶enheimer and Maurer, ̶ ̶ ̶ ̶ ̶ ̶ ̶ ̶ ̶ ̶ ̶ ̶ ̶ ̶ ̶Subsequently, Alfy, as his ̶ ̶ ̶ ̶ ̶ ̶ ̶ ̶ ̶ ̶was employed by A. ̶ ̶ ̶ ̶ ̶ ̶ ̶ompany. Between 1885 ̶ ̶ ̶ ̶ ̶ ̶ ̶asses at the National ̶ ̶ ̶ ̶ ̶ ̶ ̶ught by the conserva- ̶ ̶ ̶ ̶ ̶ ̶day-morning courses

1.
Alfred Stieglitz (American, 1864–1946)
Alfred Maurer, 1915
gelatin silver print
9-5/16 x 7-7/16 in. (23.7 x 18.9 cm)
The J. Paul Getty Museum, Los Angeles

Louis Maurer expected his children to emulate his carefully orchestrated life. In 1884, after rising through the ranks at Currier and Ives, he retired at fifty-two to live the life of a country squire. He joined a gentlemen's club and spent his days amusing himself playing golf and taking painting classes at the Gotham Art School and the National Academy of Design, where he studied under William Merritt Chase.[2] His eldest son, Charles, followed his lead, becoming a commercial printer. But his younger son had other ideas. Impressed first by Chase's impressionistic and light-filled paintings of genteel domestic scenes and later by James Abbott McNeill Whistler's tonal harmonies, Alfy began experimenting with nonrepresentational color and a more gestural brush. By embracing modernist innovations, he rejected his father's illustrative and narrative style. As young Maurer's interest in modernism developed, Louis became more reactionary, routinely criticizing his son's work and even publicly ridiculing his fauvist canvases when they were first shown at Alfred Stieglitz's 291 gallery in March 1909.[3]

Throughout his life, Maurer would regret his lack of formal education and resent his father for withholding approval. His deep-seated insecurity about writing probably contributed to his general frustration. Because he rarely wrote letters (and those few he did write were often lost or destroyed) and because he did not keep a diary or notebook, little remains of the artist's own words. This reluctance to document his experiences and ideas, combined with the tendency of the press to neglect Maurer's work because it did not fit easily into a familiar "ism," makes him

somewhat elusive. Nonetheless, it is possible to imagine the effects of his father's continual rejection on the sensitive young man, who doubtless lacked self-confidence and had difficulty expressing his emotions. Maurer's public persona apparently shrouded his true feelings. Like many chronic depressives, he struggled to "put on a good face," making every effort to develop friendships and behave as though he were comfortable in the world. However, he evidently never developed intimate relationships. Maurer's biographer, Elizabeth McCausland, noted how the painter Arthur Dove, one of his few longtime friends, wrote of the artist's "'clowning' to hide his true feelings."[4] Today, more than seventy years after Maurer's death and after several decades of the "new" art history, which favors revisionism, we still have scant information about his artistic process, his attitudes, or the sources of the debilitating depression that led to his suicide in 1932 at age sixty-four.

1. On the generally indifferent response to Maurer's art, see, among others: Elizabeth McCausland, *A. H. Maurer: A Biography of America's First Modern Painter* (New York: A. A. Wyn for the Walker Art Center, Minneapolis, 1951); Sheldon Reich, *Alfred H. Maurer, 1868–1932*, exh. cat. (Washington, D.C.: Smithsonian Institution Press for the National Collection of Fine Arts, 1973); Jonathan Goodman, "Re-Seeing Alfred H. Maurer," *Arts Magazine* 64, no. 3 (November 1989): 64–67; and Stacey B. Epstein, *Alfred H. Maurer: Aestheticism to Modernism*, exh. cat. (New York: Hollis Taggart Galleries, 1999).

2. Nicholas Madormo, "The Early Career of Alfred Maurer: Paintings of Popular Entertainments," *American Art Journal* 15, no. 1 (winter 1983): 32.

3. James R. Mellow, "The Maurer Enigma," *Arts* 34, no. 4 (January 1960): 30–35. Louis Maurer's reaction to his son's show at 291 is well documented in the literature on the artist. He ridiculed the works on view, asking Stieglitz, "Who will buy such stuff?"

4. McCausland cites Dove's remark in a list of questions for Fra Dinwiddie Dana, February 25, 1948, exhibition records, Maurer 1949, archives, Walker Art Center, Minneapolis. Dana was another of Maurer's few good friends. McCausland, *A. H. Maurer: A Biography*, 91, asserts that "Dove, more than anyone else, understood Maurer's interior life."

2.
Louis Maurer (American,
b. Hessen [Germany], 1832–1932)
Preparing for Market, 1856
hand-colored lithograph
19 x 27 in. (48.3 x 68.6 cm)
Museum of the City of New York
The Harry T. Peters Collection

The permanent collection of the Frederick R. Weisman Art Museum in Minneapolis includes 644 paintings and works on paper by Alfred Maurer, gifts and bequests of Ione and Hudson D. Walker and other members of the Walker family. The present exhibition consists of fifty-two paintings, drawings, watercolors, and gouaches drawn from those holdings. To convey Maurer's diversity and innovation, it takes us from his accomplished academic pastel of his sister, *Eugenia* (1896–97, CAT. NO. 1, P. 16), to the idiosyncratic cubism of *Two Heads* (CIRCA 1930, CAT. NO. 52, P. 65). A full range of his fauvist landscapes and still lifes, Cézannesque watercolors, bold nudes, haunting portraits, and delicate drawings reveals a mercurial artist and an isolated man.

We have a glimpse of Maurer's youthful optimism in his vibrant *Self-Portrait* (1897, CAT. NO. 2, P. 15), painted just before he departed for Paris in November 1897, aboard the *U.S.S. Rotterdam*.[5] With this bold canvas he has embarked on a path very different from his father's — into uncharted territory on the threshold of the modern age. The rapid acceleration of Maurer's development is obvious here, given that he had painted the portrait of his sister only months earlier. This elegant and true likeness proves that he had mastered the representational rendering, balanced composition, and harmonious colors of the established academy his father championed. Had Maurer continued in this conventional vein, he doubtless would have won an avid following. In fact, *Girl in White* (CIRCA 1901, FIG. 3) is a prime example of his mastery of Whistler's subdued tonalities, to which he adds a psychological emphasis in the expectant gesture of the woman's hand that is just about to propel her beyond the shallow, almost monochromatic space. This stunning canvas, together with the celebrated *An Arrangement* (1901, FIG. 4) shows Maurer at his Whistleresque best.[6] He could have satisfied both the viewing public and his demanding father by resting on his laurels and building a comfortable, conservative career. Instead, he took a radical departure with *Self-Portrait*. Here the high contrast and loose brush may reveal his brief exposure to William Merritt Chase.[7] Using the Renaissance conceit of a light source flowing from a window behind the sitter's shoulder, he lends a dynamic contour to the face and illuminates the brilliant yellows and whites. Maurer appears the self-assured artist, a dashing character — although he stood only five feet four inches tall — in his dark smock with a stylish moustache and a direct gaze. Considering how both his personal and professional lives subsequently unfolded, the portrait is especially poignant.

3. below left:
Girl in White, circa 1901 (cat. no. 3, detail)

4. below:
Alfred H. Maurer
An Arrangement, 1901
oil on cardboard
36 x 31-7/8 in. (91.4 x 81 cm)
Whitney Museum of American Art, New York
Gift of Mr. and Mrs. Hudson D. Walker

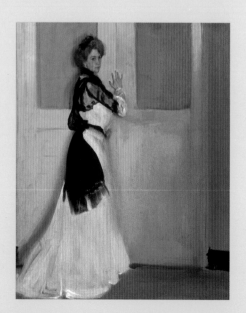

Maurer was twenty-nine years old when he arrived in France, and he quickly assimilated Parisian art-world developments. In her thorough 1951 biography of the artist, Elizabeth McCausland documented the few known details of his French experience.[8] In early December 1897, he enrolled at the Académie Julian — one of several Paris schools Americans favored — but attended classes for only three weeks.[9] During his first years in the French capital, Maurer apparently tried to work in both the commercially successful aesthetic, Whistleresque mode and in an increasingly progressive style. He painted *Girl in White* during the same period, between 1900 and 1907, when he made a series of café and genre scenes reminiscent of work by Robert Henri and other Ashcan School painters (FIG. 5).[10] This was one of several important transitional phases in Maurer's career. The palette of these interiors remains a dark range of browns but with brilliant, high-keyed colors breaking through, and the subjects are colloquial. After capturing these commonplace scenes of Parisian life, the artist entered a very different period, one that in many ways determined the evolution of his career.

Although he had acquired substantial training in the United States, Maurer received his most meaningful education in the Paris home of Gertrude Stein and her brother, Leo. By 1905 he was a regular guest at their famous salons at 27 rue de Fleurus, where he may have been the first American to see their exceptional collection of paintings by Paul Cézanne and Henri Matisse. At that time, Matisse was a popular teacher and the recently acknowledged leader of the fauvists. When asked about the precepts of fauvism, he said: "The artist, encumbered with all the techniques of the past and present, asked himself, 'What do I want?' This was the dominating anxiety of Fauvism. If he starts within himself, and makes just three spots of color, he finds the beginning of a release from such constraints." [11] Maurer, who never studied with the master, seems to have absorbed Matisse's philosophy directly from the Frenchman's canvases. The overall composition and nonrepresentational color emphasize the subjective tendencies Maurer appreciated in Chase and Whistler, qualities that defy the academic traditions he had left behind.

5.
Robert Henri (American, 1865–1929)
Café at Night, Paris, 1899
oil on canvas
32 x 35-1/2 in. (81.3 x 90.2 cm)
Lehigh University Art Galleries, Bethlehem, Pennsylvania
Museum Operation Permanent Collection

5. Epstein, *Alfred H. Maurer,* 13.

6. *An Arrangement* won a first prize in the Carnegie Institute's *Sixth Annual International Exhibition* in 1901. Vicky A. Clark et al., *International Encounters: The Carnegie International and Contemporary Art, 1896–1996* (Pittsburgh, Pa.: Carnegie Museum of Art, 1996), 152.

7. Epstein, *Alfred H. Maurer,* 12.

8. McCausland, *A. H. Maurer: A Biography,* 49–98.

9. Epstein, *Alfred H. Maurer,* 13.

10. Madormo, "The Early Career of Alfred Maurer," 8. Henri was in Paris from 1898 to 1900.

11. Matisse quoted in John Elderfield, *Matisse in the Collection of the Museum of Modern Art* (New York: Museum of Modern Art, 1978), 41.

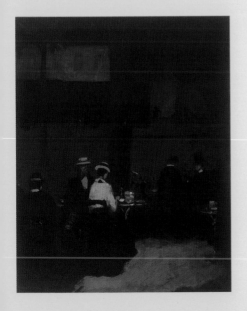

Apparently, Maurer began following the fauvist path almost immediately after his first exposure, but it is not known precisely when his first postimpressionist canvas appeared. In fact, no completely accurate account of Maurer's seventeen years in Paris (interrupted only by an extended visit to New York in 1901) exists. When he abruptly departed in August 1914, just as World War I erupted, he left his studio full of paintings. He assumed he would return to Paris soon, blithely anticipating a minor conflict. In 1925, a decade after he had returned to New York, his work in Paris was sold to pay back rent on his studio there. Maurer blamed his father for refusing to give him the money to ship what has been estimated to be hundreds of canvases to New York.

His extant fauvist paintings show Maurer fully engaged in Matisse's aesthetic. In *Still Life* (CAT. NO. 14, P. 26), painted around 1908, the composition is compressed into an airless space where background and foreground are considered equally. The upturned table edge and bowls seen from above are quotes from Cézanne and follow the modernist tenet of acknowledging the picture plane (FIG. 6). In *Landscape with Trees* (1909, CAT. NO. 5, P. 19), Maurer eagerly embraces an increasingly personal expression. The vibrant colors and sense of movement are exhilarating. For Maurer, as for Matisse, direct visual experience was paramount. Color seemed to liberate him, allowing him to escape the prescribed world he had left behind in America. He may have seen one of Matisse's landscapes, such as *Landscape at Collioure* (1905, FIG. 7), in which a similar abbreviated brushstroke allows the primary colors to remain distinct, while the overall application of pigments makes the scene nearly abstract.

During this productive period, from about 1905 to 1914, Maurer associated with American colleagues in Paris. The American impressionists Frederick Frieseke, Richard Emil Miller, and Lawton Parker and the romantic Henry Ossawa Tanner were enrolled at the Académie Julian, which, as noted, Maurer attended briefly. Earlier, he had rented a studio where George Luks and an American couple named James and May Preston were fellow tenants.[12] William J. Glackens was a friend of the Prestons, and he probably met Maurer in their company. While he gravitated to these Americans, Maurer apparently did not establish strong ties with French artists. Perhaps during his first years in Paris he was still honing his French and the language barrier made him insecure. It is more probable, however, that Maurer, like many expatriates, felt somewhat detached from the local culture, even as his affection for the city grew. This social distance may have affected the evolution of his work; his sustained affiliations with American artists in France seemed to take precedence over close personal associations with French artists.

6. below left:
Paul Cézanne (French, 1839–1906)
Still Life, circa 1900
oil on canvas
18 x 21-5/8 in. (45.7 x 54.9 cm)
National Gallery of Art, Washington, D.C.
Gift of the W. Averell Harriman Foundation
in memory of Marie N. Harriman

7. below:
Henri Matisse (French, 1869–1954)
Landscape at Collioure, 1905
oil on canvas
15-1/4 x 18-3/8 in. (38.8 x 46.6 cm)
The Museum of Modern Art, New York
Gift and bequest of Mrs. Bertram Smith

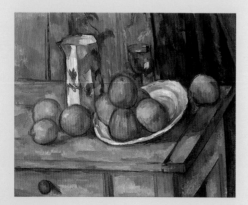

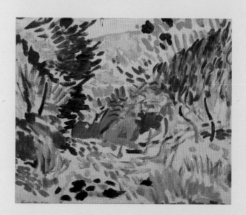

There are numerous accounts of Maurer as a dapper man about Paris. Having arrived there somewhat earlier than many of his compatriots, he was considered well informed and connected. He often provided Americans with introductions to the Steins and to prominent dealers. From 1912 to 1914, Glackens enlisted Maurer's assistance when the Philadelphia collector Albert C. Barnes was seeking acquisitions in Paris. Maurer received commissions from Barnes for locating works of art, bidding at auctions, and arranging for framing and shipping. In 1913, along with twenty-four other Americans, including Patrick Henry Bruce, Samuel Halpert, John Marin, and Edward Steichen, Maurer was given the honor of being named a *sociétaire*, or member, of the Salon d'Automne. Yet in spite of socializing with American friends and exchanging art-world gossip, Maurer remained an obscure presence. Although he evidently tried hard to establish meaningful relationships, he also appears to have been basically so ill at ease in personal relations that his acquaintances never really knew him.[13]

The literature on Maurer includes fleeting references to the possibility that he had various romantic relationships with women while in France. One persistent rumor has it that when he was about to return to the United States in 1914, a woman with whom he was associated became so despondent that she committed suicide by throwing herself out a window of his apartment at 9 rue Falguière. This story is apparently apocryphal.[14] There are also the predictable assumptions that Maurer was a homosexual. Yet no evidence exists that he developed physical relationships with individuals of either sex. Maurer's profound alienation persisted and is perhaps the single most determining factor in his work, which became increasingly introspective, as if the artist substituted a dialogue with pigment and imagery for human intimacy.

From about 1902 to 1914, Maurer painted many of his fauvist landscapes *en plein air* outside Paris, in the villages of Chezy-sur-Marne and Chalons-sur-Marne. These respites from the capital also enabled him to go fishing, a leisure pursuit he enjoyed during much of his life. On August 17, 1914, two weeks after World War I broke out, Maurer was in Chezy, fishing and painting.[15] In a letter he wrote that day to his friend Fra Dinwiddie Dana, he described his belated awareness of unfolding events:

12. Epstein, *Alfred H. Maurer*, 18–19.

13. On the nature of Maurer's interpersonal relationships, see, among others: Carle Michel Boog to Elizabeth McCausland, September 28, 1949, exhibition records, Maurer 1949, archives, Walker Art Center, Minneapolis ("But poor Alfy was ostracized by both the Art Critics and his friends."); Abram Lerner, foreword to Judith Zilczer, *Alfred H. Maurer*, exh. cat. (Washington, D.C.: Smithsonian Institution Press for the Hirshhorn Museum and Sculpture Garden, 1979) ("Maurer's determination to carry on his formal experimentation isolated him more than most and must have plunged him into the black despair that finally destroyed him," n.p.); Clement Greenberg, "Van Gogh and Maurer," *Partisan Review* 17, no. 2 (February 1950) ("Until 1914 he was able to mitigate the isolation by living in Paris, but the neglect persisted and survived him," 172); and Elizabeth McCausland, *A. H. Maurer, 1868–1932*, exh. cat. (Minneapolis: Walker Art Center, 1949) ("Many snapshots survive, showing Alfy with young people from [New York] who went [to Marlboro] for summer vacations. With them he swam, danced, and played croquet. In these photographs he stands apart, observing gaiety but of that gaiety," 15).

14. In a list of questions for Fra Dana, Elizabeth McCausland writes, "What about the story which keeps coming up that he was ordered back to the United States by his father, leaving behind his German-born sweetheart and that she, in grief, committed suicide by jumping from the window of their apartment in to the courtyard?" February 23, 1948, exhibition records, Maurer 1949, archives, Walker Art Center, Minneapolis. There is no known record of a reply by Dana. Mellow, "The Maurer Enigma," 32, also makes a passing reference to this supposed situation.

15. McCausland, *A. H. Maurer, 1868–1932*, 13.

I was caught in the country right on the line of mobilization, saw train loads of soldiers going to the front and never thought a thing about it. Was trying to work, thinking of painting [. Whe]never any talked of war to me I was more than convinced it was impossible. . . . I could hear the trains going by more than usual, and over night I was trapped.[16]

As noted, Maurer left France almost immediately thereafter, abandoning the contents of his studio and sailing for New York. Although he assumed he would shortly return to his beloved Paris, he never did. Nor did he ever regain the independence and self-determination he had achieved while living away from his family.

Maurer's life from his return in 1914 until 1924 is virtually undocumented.[17] But we know he moved back into his parents' home at 404 West Forty-third Street in Manhattan, resuming his role as the quiet younger son repressed by a dominant and self-satisfied father. The domestic tension apparently drove him to spend the summers of 1915 and 1916 at the Shady Brook boardinghouse in the village of Marlboro, New York. He later sought refuge with the painter Arthur Dove and his wife, Helen Torr, in Westport, Connecticut, visiting their home for extended periods through 1920. Maurer and Dove fished and painted together, and Maurer doted on Arthur and Helen's young son, William, for whom he carved casting plugs that are sculptural in their simplicity. Both these respites were pivotal experiences that would ultimately result in dramatic changes in Maurer's methods and style. For example, landscapes from this period are more abstract, with generalized forms that suggest rather than describe mountains, trees, and sky. And the colors he favored at this time are more subtle washes applied with broader gestures, as in a landscape of 1916–18 (CAT. NO. 9, P. 23). These emotive paintings may reflect Dove's influence.

Maurer's supportive mother, Louisa, died in December 1917. Her death created a void in the household that was never filled, and the estrangement between Alfred and his father worsened. After his sister, Eugenia, married and left home, he lived with his father for the rest of his life.

The animosity the two men felt toward one another was masked only by a modicum of decorum, but the stress between them seems to have been constant and palpable. Maurer's willingness to endure Louis's diatribes against his modernist art again reveals the younger man's immature personality; even now, in middle age, he was unable to defend his work or to extract himself from his demeaning living situation.

Around 1919 Maurer stopped painting his abstract landscapes and introduced his perplexing so-called sad girl portraits, the subjects of which may have been fellow Shady Brook summer residents or the mothers of children for whom he bought ice cream in Marlboro.[18] Usually painted in tempera and/or gouache that Maurer mixed himself, these enigmatic portraits do not reveal their sitters. Rather the women are rendered iconic, each with large eyes and a masklike face; they are remote presences posed in cool, non-specific settings — for example, *Girl* (CIRCA 1923, CAT. NO. 20, P. 33). The art historian Sheldon Reich attributed these simplified likenesses to Maurer's awareness of African sculpture and particularly of Pablo Picasso's *Les Demoiselles d'Avignon* (1907).[19] But unlike Picasso, Maurer places his isolated, three-quarter figures against angled fields of color that articulate rather than fracture the space. The centrality of the figures and the receding space are departures from his compressed fauvist compositions and are additional evidence of his ability to embrace disparate aesthetics.

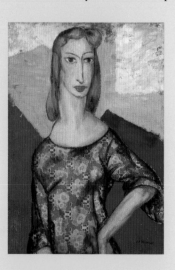

8.
Portrait of a Girl in a Flowered Dress, 1924
(cat. no. 22)

In 1924 Maurer's professional situation improved somewhat, albeit temporarily. Since returning to the United States, he had endured years of critical neglect, exhibiting his work only intermittently and selling virtually nothing. Then, unexpectedly, the art and book dealer Erhard Weyhe purchased the contents of his studio — 255 works in all — and also agreed to provide him with an annual stipend: Maurer would supply Weyhe with twenty to thirty watercolor paintings for which he would be paid thirty-five dollars apiece.

The magnitude of the Weyhe transaction and the recognition it accorded Maurer gave the artist a renewed sense of confidence and heralded a period of extraordinary experimentation and versatility. Always willing to consider new stylistic approaches, he now also pursued innovative methods. In an addendum to her Maurer biography, Elizabeth McCausland documents the variety of his techniques — and, unfortunately, the resultant deterioration of many of his paintings.[20] His experiments ranged from using canvases that incorporated mattress ticking, cardboard, or paper to grounds made from dental plaster and thick gesso to pigments and glazes that were not always stable.

Maurer's innovations took an eccentric turn with his female portraits of the mid-1920s. The Weisman Art Museum collection includes *Portrait of a Girl in a Flowered Dress* (FIG. 8) and *Portrait of a Girl* (CAT. NO. 23, P. 35), both from 1924. No doubt inspired by Dove's use of collage (FIG. 9), Maurer achieved collage effects by means of a novel technique. Other artists, including Dove, Picasso, and Georges Braque, integrated collage elements into complex compositions and often sought a trompe l'oeil effect by juxtaposing the actual textures of found materials with painted areas of the canvas. Maurer, however, used collage as an underlying support for the composition as a whole. With both *Portrait of a Girl in a Flowered Dress* and *Portrait of a Girl*, he stretched dime-store dress fabric over the entire surface of wallboard, which he generally used during this period instead of canvas. Next he applied sizing, followed by a gesso ground to secure the fabric. He then painted over the fabric, leaving the areas representing the girls' dresses exposed and in-painting the drapery folds to suggest their breasts and bent elbows. Without Maurer's commentary, we can only speculate about his process. Was the unusual use of fabric as a ground a simplistic approach to collage? Was this an innovative reverse-collage technique? Or was it a peculiarly American reworking of the French visual pun? Whatever his intention, Maurer turned collage in on itself, using the printed fabric to represent its intended end product, a dress. Where collage is typically used to subvert representation — that is, to represent an aberrant element in a painting — he employed it as if it were another pigment on his canvas.

9.
Arthur G. Dove (American, 1880–1946)
Grandmother, 1925
collage of shingles, needlepoint, page from the Concordance, pressed flowers, and ferns, mounted on cloth-covered wood
20 x 21-1/4 in. (50.8 x 54 cm)
The Museum of Modern Art, New York
Gift of Philip L. Goodwin (by exchange)

16. Maurer letter as transcribed in Fra Dana to D. S. Defenbacher, Walker Art Center, February 5, 1948, exhibition records, Maurer 1949, archives, Walker Art Center, Minneapolis. "You see he was so interested in painting that he did not even sense that there was a war," Dana comments. "So like him."

17. McCausland, *A. H. Maurer, 1868–1932*, 15.

18. "Juliette R. Warnken said these [the painting *Two Sisters* lent by E. Weyhe] 'could be Margaret and Elizabeth Schramm.' Mrs. Frederick W. Schramm, Sr., corroborated, as did Myrtle B. Bjornson." Elizabeth McCausland note, 1948, exhibition records, Maurer 1949, archives, Walker Art Center, Minneapolis.

19. Reich, *Alfred H. Maurer, 1868–1932*, 102.

20. McCausland, *A. H. Maurer: A Biography*, 271–74.

The women in the Weisman Art Museum's collage portraits have more relaxed postures and emotive faces than the subjects of his tempera and gouache portraits of the previous year. Maurer has even given them contemporary hairstyles, rosy cheeks, and lipstick. Yet they remain aloof. The identities of these models are not known, but the girl in the flowered dress seems to reappear in some of his late expressionistic portraits. Abstract planes of color fill the background, completing a triad of realisms — collaged fabric, naturalistic features, and blocks of color.

Maurer returned to the visual riddles offered by collage in a group of still lifes incorporating the novel element of a stenciled doily. *Still Life with Cup* (CIRCA 1929, CAT. NO. 19, P. 31), painted in oil on composition board, is a cubistic view of a tabletop with a cup and plate. The real focal point, however, is the doily that he stenciled, first in black paint and then in white. The two layers are superimposed on each other four times, establishing another confounding parody of realism. While Picasso might have inserted an actual doily into the painted surface, Maurer used paint to represent and then reiterate the doily. His innovative illusions make the collage works and *Still Life with Cup* some of the most sophisticated paintings in his oeuvre.

In 1927 Maurer began renting a studio in the Lincoln Square Arcade Building at Broadway and Sixty-sixth Street, where he worked until his death. For the first time, he employed a model one day a week. He also renewed his interest in the theories of the artist-illustrator Jay Hambidge, whose lectures he had attended in Paris. Hambidge attributed his ideas about beauty and design to the ancient Greek system of dynamic symmetry, which bases all design on the harmony of human and plant forms. Like many American painters of the period, Maurer studiously applied Hambidge's lessons of proportioning based on diagonals and rectilinear organization.[21]

Maurer's series of large-scale oil nudes in the Weisman collection — *Nude* (1927, FIG. 10), *Standing Female Nude* (1927-28, CAT. NO. 26, P. 58), and *Standing Female Nude* (1928, CAT. NO. 31, P. 53) — shows his studio environment reinterpreted according to Hambidge's lessons, while the figures' lack of sensuality recalls Cézanne's stolid bathers (FIG. 11). Specifically, the 1927 *Nude* combines a foreshortened checkerboard-patterned floor, a severely angled tabletop projecting into the center of the foreground, curtains articulated by vertical lines, and a naturalistic female nude in a contrapuntal pose. The structural elements of the space and the graphic rhythm of the floor embrace a basic symmetrical composition. The figure, with its modeled skin tones, gestural brushstrokes, and suggestion of movement, serves as a counterpoint to the architectural devices. Maurer simultaneously deals with a quasi-cubistic fracturing of space and an almost classical approach to rendering the nude, creating a personal duality of the figure and its spatial coordinates.

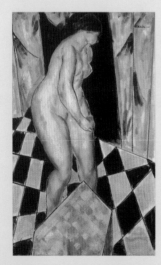

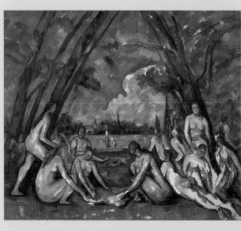

10. far left:
Nude, 1927 (cat. no. 24)

11. left:
Paul Cézanne (French, 1839–1906)
The Large Bathers, 1906
82-7/8 x 98-3/4 in. (210.5 x 250.8 cm)
oil on canvas
Philadelphia Museum of Art
Purchased with the W. P. Wilstach Fund

With *Contortionist* (1927–28, FIG. 12), Maurer continues the symmetrical composition seen in the aforementioned nudes but achieves uncommon theatricality with dramatic shadows and an unusual pose. A directed light shines on the figure as she executes a limber handstand on a pedestal. The arrested motion is set against a bright flowered wallpaper. The combination of unusual subject matter, severe lighting, and ornate backdrop makes this painting one of his most eccentric. Three associated drawings (FIG. 13; CAT. NO. 43, P. 47; AND CAT. NO. 44, P. 48) suggest he was examining complex postures in order to make rapid analyses of sequential motions. There was a photography darkroom in the basement of Maurer's family home, and although there are no extant photographs by him, he may have derived these drawings and those of other briefly held poses from photographs he took of his model.[22]

Drawings were an important part of Maurer's process. The Weisman Art Museum collection includes numerous undated sketches that document the artist's versatility and reveal an ease that is not always apparent in his paintings. The drawings in graphite or India ink on paper may record his efforts to determine the general compositional structure of a landscape (such as the undated CAT. NO. 12, P. 25) or the lines of a figure he intends to emphasize. Among the works in this exhibition are several more finished drawings, such as *Reclining Figure* (CIRCA 1927–28, FIG. 14), a delicate study of a woman's back. This small graphite and charcoal on paper conveys a sensitivity toward the female subject that is often lacking in Maurer's other nudes. Perhaps the model's relaxed pose and the fact that she is not facing the artist allowed him to respond with more tenderness than he could achieve in a direct encounter.

Sometime during the late 1920s, Maurer made a series of large-scale gouache-and-watercolor studies of nudes on paper that are reminiscent of Cézanne's bathers. The Weisman group includes two double subjects, both entitled *Two Figures* (both CIRCA 1927–28, CAT. NOS. 28 AND 30, PP. 55, 54). Maurer's use of the double may simply be a representational depiction of two women, but it is tempting to consider the metaphorical meanings of doubles. On a purely formal level, he might have been attempting alternative resolutions to the problems of a single portrait, or he may have been attempting an idiosyncratic form of cubism, with the double representing different facial expressions simultaneously. The validity of these explanations can be argued, but the evolution of the series of doubles paintings suggests that Maurer was wrestling with questions of identity and interpersonal communication.

21. Reich, *Alfred H. Maurer, 1868–1932*, 78, notes Maurer's hiring of a model and attendance at Hambidge's lectures. For Hambidge's theories, see Jay Hambidge, *The Elements of Dynamic Symmetry* (1926; reprint, New York: Dover, 1967).

22. Madormo, "The Early Career of Alfred Maurer," 33.

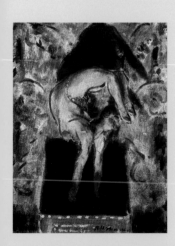

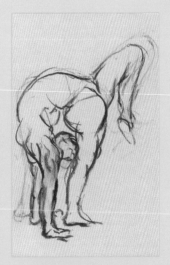

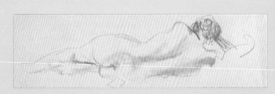

12. far left:
Contortionist, 1927–28 (cat. no. 25)

13. left:
Nude Doing Backbend, circa 1927–28 (cat. no. 42, detail)

14. above:
Reclining Figure, circa 1927–28 (cat. no. 46)

The course of Maurer's career can be variously interpreted. His predilection for changing styles and experimenting with unusual materials has sometimes made him seem derivative. Gertrude Stein's dismissive description of him — "He followed, followed, followed. Always humbly, always humbly, always sincerely" — suggests he was an emulator, a man without conviction.[23] At the beginning of his seventeen-year stay in Paris, when he first knew the Steins, Maurer probably was somewhat hesitant and, as always, socially awkward. Like most Americans painting abroad, he looked to established artists for direction; Cézanne and Matisse became his stylistic mentors, opening the path he initially followed and from which he eventually diverged. Increasingly, Maurer pursued an inner vision, one that reflected the many influences he had absorbed.

Five paintings, in particular, dating from 1928 to 1930, provide a tantalizing and disturbing glimpse of the artist's final creative efforts. The cool and distant portraits of about 1923 have mutated into *Head of a Girl* (1929, CAT. NO. 50, COVER AND P. 60) and *Portrait of a Girl with Gray Background* (CIRCA 1930, FIG. 15), two expressive canvases that hint at Maurer's personal reality. In *Head of a Girl*, the more decorative of the two, the head is framed by what seems to be a proscenium, complete with symmetrical drapes framing the subject. Her neck rises like an Ionic column from the array of greens in the foliage and in her dress. Her long,

angular nose accentuates her long, narrow face with its large, haunting eyes. She stares past the foliage like an exotic creature. These eyes seem to see beyond the picture plane and into an existential void. Do they belong to the sitter, or are they Maurer's?

About a year after he painted *Head of a Girl*, Maurer produced *Portrait of a Girl with Gray Background*, which is stark and stripped of the softening details, such as contemporary hairstyles, rosy cheeks, and feminine costumes, with which he endowed earlier portraits. The subject's neck and shoulders and the minimal background appear to have been rubbed or sanded down, and that spareness reinforces the pale, almost monochromatic palette. The large head with its wan skin and dour mouth suggest a shy, reticent girl. Her round, desperate-looking eyes gaze fixedly at us. With this unembellished face that evokes a solitary life circumscribed by disappointment and suspicion, Maurer proved himself to be a risk taker who had moved far beyond the early portrait of his sister.

15. below left:
Portrait of a Girl with Gray Background,
circa 1930 (cat. no. 51)

16. below:
Two Heads with Yellow Background,
1928–29 (cat. no. 48)

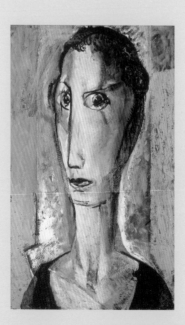

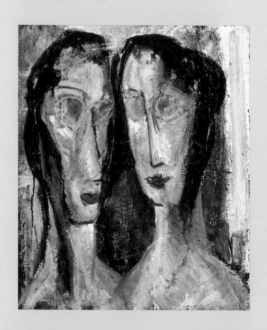

In his final years, Maurer returned to the twin theme, and three canvases in the Weisman collection exemplify his increasingly deconstructed vision. *Two Heads with Yellow Background* (1928–29, FIG. 16) has a rubbed, sanded, and scraped surface similar to that of *Portrait of a Girl with Gray Background*. But instead of a limited palette, the violent color of the double portrait accentuates the emotional content. Reds, pinks, and yellows applied in broad, aggressive strokes define the skin tones. Again the eyes loom large, but here thin veils of paint obscure them. The two figures are joined at the shoulders and by their hair; between these junctures is a dark void. Whether Maurer has painted two individual women or two views of one woman is hardly relevant: the real subject is his contemplation of the Other. Questions about how one person can communicate with another, how one person perceives another, and how all people are ultimately unknowable were no doubt on the mind of this lonely and by now almost completely isolated man.

During the same period, Maurer made a quasi-cubist rendition of the double portrait entitled *Two Heads* (1928–30, FIG. 17). This recent addition to the Weisman collection translates the expressionist *Two Heads with Yellow Background* into a study of planar construction. The women of the 1928–30 *Two Heads* have a similar duality. Their foreheads touch, and their faces are turned slightly toward each other. The dark interstices of the earlier painting have become an irregular rhomboid shape, while the light cast on their faces is faceted into parallel vertical segments. The horizontal traversing the upper quadrant of the picture further emphasizes the verticality and creates a box-like framework that is superimposed over the composition. The stylized details of the subjects' coiffures lend a note of whimsy to the abstracted portraits. Maurer liberally worked the surface, applying numerous washes of color to the simplified images. He apparently was seeking, if not struggling, to achieve a personal interpretation of analytic cubism, even though most American artists in the late 1920s and early 1930s were increasingly gravitating toward representationalism and away from the experimentation that had originally defined cubism. By this time, two years before his death, Maurer was detached from the American art world and from the mainstream tendencies of social realism and regionalism it supported. In 1950 the preeminent modernist critic Clement Greenberg wrote that Maurer was "one of the handful of painters who stayed close to the original conception of Cubism promulgated by Picasso and Braque without mechanically duplicating it or sacrificing their personalities."[24]

23. Gertrude Stein, *The Autobiography of Alice B. Toklas* (1933; reprint, New York: Vintage Books, 1990), 14.

24. Clement Greenberg, "Van Gogh and Maurer," *Partisan Review* 17, no. 2 (February 1950): 173.

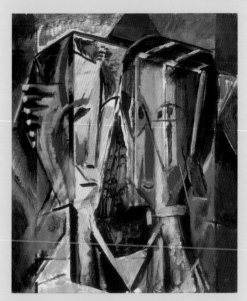

17.
Two Heads, 1928–30
(cat. no. 49, front)

The last double portrait of the three in the Weisman collection is *Two Heads* (CIRCA 1930, FIG. 18), a painting that further exemplifies Maurer's persistent internal aesthetic. Here the two women are both physically and emotionally detached. The artist's foray into cubism takes a decorative turn as he dwells on the headdresses and the patchwork of textures that form the two faces. Gone are the angst, the hollowed-out eyes, and the scratchy surfaces. Instead, the "sisters" serve as foils for the decorative devices of symmetry, appealing colors, and controlled patterning. From *Two Heads with Yellow Background* to this *Two Heads*, Maurer seems to be retreating from his subjects — and perhaps from the world.

In 1928 Maurer was treated for a benign prostatic growth. This was the same year when his father was recognized and celebrated as the last of the living Currier and Ives artists. At ninety-six, Louis Maurer was basking in what he considered well-deserved glory, conducting interviews and posing with his paintings for an avid press. During his final years, Alfred suffered the dual humiliations of being almost totally neglected by critics and dealers while witnessing the celebration of his difficult father's artistic legacy. The contrast between the reception accorded the two artists' work reflects the isolationism that prevailed in the United States between the world wars and the accompanying rejection of European influences fundamental to Alfred Maurer's art. While Louis Maurer's folksy scenes of the Wild West satisfied the popular taste for Americana, his son's commitment to modernism was increasingly out of favor.

In February 1932, Louis enjoyed a final flurry of press attention when he celebrated his one-hundredth birthday. Alfred turned sixty-four that year, on April 21, the same day he entered the hospital for a prostatectomy. The surgery was successful, and he was discharged on June 29 in excellent condition. But he quickly descended into a severe depression. Louis died on July 19, and on August 4, Alfred climbed to his room on the third floor and hung himself. Maurer's acquaintances were dismayed and evidently startled by his suicide, citing his forthcoming inheritance and his plans to return to Paris as reasons for his presumed optimism. But Arthur Dove, his closest friend, was not surprised. Five years later, he wrote about his last visit with Maurer, who was recuperating from surgery: "I knew then he had no interests left here. Could feel him being brave and clowning the whole thing, and yet being in a hurry to take off." [25]

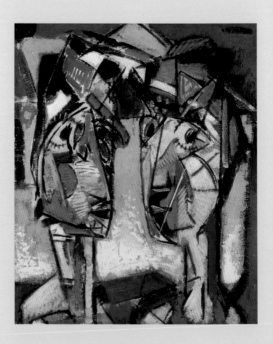

18.
Two Heads, circa 1930
(cat. no. 52)

Maurer's legacy was secured by the work he made from 1924 until his death. Increasingly introspective, the portrait heads were both provocative in their stylistic and technical diversity and stultified insofar as they mirrored the artist's frustrations. The complex structures and varied aesthetics of his heavily reworked paintings suggest a frantic struggle for resolution and clarity. Writing in 1949, *Art News* editor Thomas B. Hess considered the "lack of toughness in structure and conception [to be] Maurer's greatest weakness."[26] Dove expressed a similar posthumous criticism when he referred to Maurer's "facility" as the greatest threat to his artistic maturation.[27] Dove's reservation was a response to his friend's feverish productivity and tendency to move quickly to the next project rather than to ruminate over difficult issues. This aversion to probity may reflect Maurer's personality and his inability to resolve profound familial problems. Under the profusion of colors and styles that distinguishes his work, there exists a quiet tension. Despite his willingness to experiment and to pursue his own vision, Maurer seemed encumbered by his psyche and thus never truly realized his potential as a modernist. It is the disparity between Maurer's efforts and his frailties that does much to make his work poignant and compelling.

Although largely unappreciated during his lifetime, Maurer posthumously achieved critical status as an individualist. As the critic Lewis Mumford observed two years after the artist's death, "Maurer was one of the handful of genuine moderns who really felt abstractions as experiences."[28] Increasingly, his introverted modernism is celebrated as a quintessentially American vision. His restless spirit and valiant pursuit of an authentic expression are now recognized as the distinguishing hallmarks of a genuinely original artist, one whom Clement Greenberg referred to as "perhaps the only authentic cubist we have produced."[29] Formally trained and directly exposed to the early twentieth century's most revolutionary artistic ideas, Alfred Maurer became his own most powerful influence. The conditions of his personal life and the limitations of his personality determined the course of his creative life, leaving for posterity a remarkable assembly of paintings and drawings.

25. Dove "epitaph" quoted in McCausland, *A. H. Maurer: A Biography*, 248.

26. Thomas B. Hess, "Alfred Maurer Memorial." *Art News* 48, no. 6 (September 1949): 24–25.

27. Dove quoted in Mellow, "The Maurer Enigma," 35.

28. Mumford quoted in John Goodrich, "Alfred H. Maurer," *Review: The Critical State of Visual Art in New York* (December 15, 1999): 23.

29. Clement Greenberg, *Nation* 165, no. 25 (December 20, 1947): 687.

Works in the Exhibition

All works listed here are by Alfred Maurer and are part of the Frederick R. Weisman Art Museum collection. Except where noted, works are bequests of Hudson D. Walker from the Ione and Hudson D. Walker Collection.

NOTES TO THE READER:
Dimensions are given in inches and centimeters; height precedes width. For works on paper, dimensions reflect image size.

The abbreviation "n.d." means the date is not known.

Research for this exhibition has clarified the record about certain works, with the result that particular title and date information may appear differently in this catalogue than in previously published books and articles.

EARLY WORKS

1.
EUGENIA MAURER, *1896–97*
PASTEL ON PAPER ON FABRIC
32 X 22 (81.3 X 55.9)
GIFT OF IONE AND HUDSON D. WALKER
1953.179

2.
SELF-PORTRAIT, *1897*
OIL ON CANVAS
28-3/4 X 21 (73 X 53.3)
GIFT OF IONE AND HUDSON D. WALKER
1953.301

3.
GIRL IN WHITE, *circa 1901*
OIL ON WOOD PANEL
24 X 19-3/8 (61 X 49.2)
GIFT OF IONE AND HUDSON D. WALKER
1953.307

FAUVIST LANDSCAPES

4.
LANDSCAPE (AUTUMN), *1909*
OIL ON CANVAS
25-5/8 X 32 (65.1 X 81.3)
GIFT OF IONE AND HUDSON D. WALKER
1953.299

5.
LANDSCAPE WITH TREES, *1909*
OIL ON COMPOSITION BOARD
31-3/4 X 24-7/16 (80.6 X 62.1)
GIFT OF IONE AND HUDSON D. WALKER
1953.321

6.
LANDSCAPE, *circa 1915–24*
WATERCOLOR AND GOUACHE ON PAPER
21-1/2 X 17-7/8 (54.6 X 45.4)
1978.21.162

7.
LANDSCAPE, *circa 1915–24*
WATERCOLOR, GOUACHE, AND CHALK ON PAPER
21-1/4 X 18 (54 X 45.7)
1978.21.158

8.
LANDSCAPE, *1916*
OIL ON PAPER ON CARDBOARD
21-3/4 X 18 (55.2 X 45.7)
1978.21.159

9.
LANDSCAPE, *1916–18*
OIL ON PAPER
10 X 14 (25.4 X 35.6)
GIFT OF IONE AND HUDSON D. WALKER
1953.300

10.

LANDSCAPE, *n.d.*
CONTÉ CRAYON ON PAPER
9-3/8 X 11-13/16 (23.8 X 30)
1978.21.651

11.

LANDSCAPE, *n.d.*
CONTÉ CRAYON ON PAPER
9-3/8 X 11-7/8 (23.8 X 30.2)
1978.21.652

12.

LANDSCAPE, *n.d.*
CONTÉ CRAYON ON PAPER
9-3/8 X 12 (23.8 X 30.5)
1978.21.649

13.

LANDSCAPE, *n.d.*
CONTÉ CRAYON ON PAPER
9-1/2 X 12 (24.1 X 30.5)
1978.21.366

STILL LIFES

14.

STILL LIFE, *circa 1908*
TEMPERA ON CARDBOARD
21-1/2 X 17-7/8 (54.6 X 45.4)
GIFT OF IONE AND HUDSON D. WALKER
1953.206

15.

STILL LIFE, *circa 1910*
OIL ON CARDBOARD
21-3/8 X 17-7/8 (54.3 X 45.4)
1978.21.3

16.

YELLOW PEAR AND ROLL, *circa 1920*
OIL ON COMPOSITION BOARD
18-1/8 X 21-3/4 (46 X 55.2)
GIFT OF IONE AND HUDSON D. WALKER
1953.305

17.

BRASS BOWL, *1927–28*
OIL ON COMPOSITION BOARD
21-3/8 X 18-1/8 (54.3 X 46)
GIFT OF IONE AND HUDSON D. WALKER
1953.320

18.

ABSTRACT STILL LIFE, NO. 2, *1928–30*
GOUACHE ON CARDBOARD
9-7/8 X 15 (25.1 X 38.1)
1978.21.181

19.

STILL LIFE WITH CUP, *circa 1929*
OIL ON COMPOSITION BOARD
18-1/8 X 21-3/4 (46 X 55.2)
GIFT OF IONE AND HUDSON D. WALKER
1953.304

FIGURE PAINTINGS

20.
GIRL, *circa 1923*
GOUACHE ON PAPER
21-1/2 X 18 (54.6 X 45.7)
1978.21.141

21.
GIRL, *circa 1923*
GOUACHE ON PAPER
21-3/8 X 18 (54.3 X 45.7)
1978.21.88

22.
PORTRAIT OF A GIRL IN A FLOWERED DRESS, *1924*
CASEIN ON FIGURED FABRIC ON COMPOSITION BOARD
25-7/8 X 17-7/8 (65.7 X 45.4)
GIFT OF IONE AND HUDSON D. WALKER
1953.214

23.
PORTRAIT OF A GIRL, 1924
CASEIN ON FIGURED FABRIC ON CARDBOARD
26 X 18-1/8 (66 X 46)
1978.21.164

24.
NUDE, *1927*
OIL ON COMPOSITION BOARD
39-1/8 X 24 (99.4 X 61)
1978.21.299

25.
CONTORTIONIST, *1927–28*
OIL ON COMPOSITION BOARD
12-1/8 X 9-1/4 (30.8 X 23.5)
GIFT OF IONE AND HUDSON D. WALKER
1953.297

26.
STANDING FEMALE NUDE, *1927–28*
CASEIN ON COMPOSITION BOARD
21-13/16 X 18-3/16 (55.4 X 46.2)
GIFT OF IONE AND HUDSON D. WALKER
1953.211

27.
SEATED FIGURE, *circa 1927–28*
GOUACHE AND WATERCOLOR ON PAPER
24-5/8 X 18-7/8 (62.5 X 47.9)
1978.21.142

28.
TWO FIGURES, *circa 1927–28*
GOUACHE AND WATERCOLOR ON PAPER
21-3/4 X 17-1/2 (55.2 X 44.5)
1978.21.143

29.
FIGURE, *circa 1927–28*
GOUACHE AND WATERCOLOR ON PAPER
24-3/4 X 18 (62.9 X 45.7)
1978.21.144

30.
TWO FIGURES, *circa 1927–28*
GOUACHE AND WATERCOLOR ON PAPER
21-1/2 X 18 (54.6 X 45.7)
1978.21.145

31.
STANDING FEMALE NUDE, *1928*
OIL ON WOOD
36 X 25-1/2 (91.4 X 64.8)
GIFT OF IONE AND HUDSON D. WALKER
1953.324

FIGURE DRAWINGS

32.
BENDING FIGURE, *circa 1927–28*
GRAPHITE ON PAPER
9-3/4 X 5-1/2 (24.8 X 14)
1978.21.15

33.
BENDING FIGURE, *circa 1927–28*
CONTÉ CRAYON ON PAPER
10-3/4 X 6-3/8 (27.3 X 16.2)
1978.21.11

34.
FEMALE NUDE, *circa 1927–28*
GRAPHITE ON PAPER
10-3/4 X 10 (27.3 X 25.4)
1978.21.793

35.
FEMALE NUDE WITH RAISED ARM, *circa 1927–28*
INK ON PAPER
15-3/4 X 6-7/8 (40 X 17.5)
GIFT OF HUDSON D. WALKER
1972.16.9

36.
FIGURE, *circa 1927–28*
GRAPHITE ON PAPER
16 X 5-3/4 (40.6 X 14.6)
1978.21.538

37.
FIGURE, *circa 1927–28*
CONTÉ CRAYON ON PAPER
9-1/2 X 4-1/4 (24.1 X 10.8)
1978.21.666

38.
FIGURE, *circa 1927–28*
CONTÉ CRAYON ON PAPER
9-5/8 X 3 (24.4 X 7.6)
1978.21.541

39.
FIGURE, *circa 1927–28*
CHARCOAL ON PAPER
9-5/8 X 3-7/8 (24.4 X 9.8)
1978.21.664

40.
NUDE, *circa 1927–28*
INK AND WASH ON PAPER
14-5/16 X 7-1/2 (36.4 X 19)
1978.21.14

41.
NUDE, *circa 1927–28*
GRAPHITE ON PAPER
14-3/4 X 9-3/4 (37.5 X 24.8)
1978.21.570

42.
NUDE DOING BACKBEND, *circa 1927–28*
CHARCOAL ON PAPER
7-5/8 X 5-1/2 (19.4 X 14)
1978.21.401

43.
NUDE DOING BACKBEND, *circa 1927–28*
GRAPHITE ON PAPER
4-5/8 X 4-1/8 (11.7 X 10.5)
1978.21.419

44.
NUDE DOING HANDSTAND, *circa 1927–28*
GRAPHITE ON PAPER
6-1/4 X 3 (15.9 X 7.6)
1978.21.418

45.
SEATED FIGURE, *circa 1927–28*
INK AND WASH ON PAPER
13-3/4 X 10 (34.9 X 25.4)
1978.21.565

46.
RECLINING FIGURE, *circa 1927–28*
GRAPHITE AND CHARCOAL ON PAPER
3-11/16 X 12-5/16 (9.4 X 31.3)
1978.21.503

47.
RECLINING FIGURE, *n.d.*
GRAPHITE AND CHARCOAL ON PAPER
7-1/2 X 16-1/4 (19 X 41.3)
1978.21.345

LATE WORKS

48.
TWO HEADS WITH YELLOW BACKGROUND, *1928–29*
OIL ON COMPOSITION BOARD
21-3/4 X 18-1/8 (55.2 X 46)
1978.21.108

49.
TWO HEADS, *1928–30*
OIL ON CANVAS ON BOARD
16-3/16 X 14 (41.1 X 35.6)
GIFT OF ELVA WALKER SPILLANE
2002.13 A, B (FRONT AND BACK)*

50.
HEAD OF A GIRL, *1929*
OIL ON CLOTH ON COMPOSITION BOARD
21-1/2 X 18-1/8 (54.6 X 46)
GIFT OF IONE AND HUDSON D. WALKER
1953.315

51.
**PORTRAIT OF A GIRL WITH
GRAY BACKGROUND**, *circa 1930*
OIL ON COMPOSITION BOARD
39-1/8 X 24 (99.4 X 61)
GIFT OF IONE AND HUDSON D. WALKER
1953.306

52.
TWO HEADS, *circa 1930*
OIL ON COMPOSITION BOARD
21-1/2 X 17-7/8 (54.6 X 45.4)
GIFT OF IONE AND HUDSON D. WALKER
1953.319

*ONLY THE FRONT SIDE OF THIS WORK IS EXHIBITED.

SELECTED BIBLIOGRAPHY

DAVIDSON, M. "American Pioneer of the Modern School: Hudson D. Walker Gallery." *Art News* 36 (December 4, 1937): 11.

ELDERFIELD, JOHN. *Matisse in the Collection of the Museum of Modern Art*. New York: Museum of Modern Art, 1978.

EPSTEIN, STACEY B. *Alfred H. Maurer: Aestheticism to Modernism*. Exh. cat. New York: Hollis Taggart Galleries, 1999.

GENAUER, EMILY. "Maurer Memorial: Reminiscence, Controversy, and Applause." *Art Digest* 24, no. 4 (November 15, 1949): 7.

GLUECK, GRACE. "Diving into Modernism, School after School." *New York Times*, December 19, 1999.

GOODMAN, JONATHAN. "Re-Seeing Alfred H. Maurer." *Arts Magazine* 64, no. 3 (November 1989): 64–67.

GOODRICH, JOHN. "Alfred H. Maurer." *Review: The Critical State of Visual Art in New York* (December 15, 1999): 22–23.

GREENBERG, CLEMENT. *Nation* 165, no. 25 (December 20, 1947): 687–88.
———. "Van Gogh and Maurer." *Partisan Review* 17, no. 2 (February 1950): 170–73.

HAMBIDGE, JAY. *The Elements of Dynamic Symmetry*. 1926. Reprint, New York: Dover, 1967.

HESS, THOMAS B. "Spotlight On: Grosz, Robinson, Maurer." *Art News* 45, no. 8 (October 1946): 50–51, 77–78.
———. "Alfred Maurer Memorial." *Art News* 48, no. 6 (September 1949): 24–25.

KRAMER, HILTON. *Alfred H. Maurer: The Cubist Works*. Exh. cat. New York: Salander-O'Reilly Galleries, 1988.
———. "Alfred H. Maurer's Bold Journey from Estheticism to Modernism." *New York Observer*, December 20, 1999.
———. "Honoring Thy Father." *Art and Antiques* 23, no. 4 (April 2000): 132, 134.

KUNITZ, DANIEL. "Alfred H. Maurer: Aestheticism to Modernism." *New Criterion* 18, no. 6 (February 2000): 49–50.

LOUGHERY, JOHN. "The Watercolors of Alfred Maurer, 1926–28." *Arts Magazine* 59, no. 10 (June/summer 1985): 124–25.

MADORMO, NICHOLAS. "The Early Career of Alfred Maurer: Paintings of Popular Entertainments." *American Art Journal* 15, no. 1 (winter 1983): 4–34.

McCAUSLAND, ELIZABETH. *A. H. Maurer, 1868–1932*. Exh. cat. Minneapolis: Walker Art Center, 1949.
———. *A. H. Maurer: A Biography of America's First Modern Painter*. New York: A. A. Wyn for the Walker Art Center, Minneapolis, 1951.

MELLOW, JAMES R. "The Maurer Enigma." *Arts* 34, no. 4 (January 1960): 30–35.

POLLACK, PETER. *Alfred Maurer and the Fauves: The Lost Years Rediscovered*. Exh. cat. New York: Bernard Danenberg Galleries, 1973.

REICH, SHELDON. *Alfred H. Maurer, 1868–1932.* Exh. cat. Washington, D.C.: Smithsonian Institution Press for the National Collection of Fine Arts, 1973.

SALANDER-O'REILLY GALLERIES. *Alfred Maurer, 1868–1932: Modernist Paintings.* Exh. cat. New York: Salander-O'Reilly Galleries, 1983.

STEIN, GERTRUDE. *The Autobiography of Alice B. Toklas.* 1933. Reprint, New York: Vintage Books, 1990.

TERENZIO, STEPHANIE. *Alfred H. Maurer: Watercolors, 1926–28.* Exh. cat. Storrs, Conn.: William Benton Museum of Art, University of Connecticut, 1985.

UNIVERSITY OF MINNESOTA. *Hudson D. Walker: Patron and Friend, Collector of Twentieth-Century American Art.* Exh. cat. Minneapolis: University Gallery, University of Minnesota, 1977.

WEINBERG, H. BARBARA. *The Lure of Paris: Nineteenth-Century American Painters and Their French Teachers.* New York: Abbeville Press, 1991.

WEINBERG, H. BARBARA, DOREEN BOLGER, AND DAVID PARK CURRY. *American Impressionism and Realism: The Painting of Modern Life, 1885–1915.* Exh. cat. New York: Metropolitan Museum of Art, distributed by Harry N. Abrams, 1994.

ZILCZER, JUDITH. *The Aesthetic Struggle in America, 1913–1918: Abstract Art and Theory in the Stieglitz Circle.* Ph.D. diss., University of Delaware, 1975.

———. *Alfred H. Maurer.* Exh. cat. Washington, D.C.: Smithsonian Institution Press for the Hirshhorn Museum and Sculpture Garden, 1979.

ARCHIVES

WALKER ART CENTER, Minneapolis. Exhibition records, Maurer 1949.

Frederick R. Weisman Art Museum,
University of Minnesota, Minneapolis

FREDERICK R. WEISMAN ART MUSEUM STAFF

Lyndel King, *Director and Chief Curator*
John Allen, *Events Coordinator*
Ann Benrud, *Director of Public Affairs*
Jill Boldenow, *Public Programs Assistant*
Karen Casanova, *Director of Development*
Theresa Downing Davis, *Special Projects Coordinator*
Karen Duncan, *Registrar*
Steve Ecklund, *Preparator*
Paige John, *Administrative Specialist*
Mark Kramer, *Exhibits Coordinator*
Bill Lampe, *Building and Technical Operations Manager*
Lisa Lukis, *Development Associate*
Kay McGuire, *Museum Store Manager*
Ann Milbradt, *Education Assistant*
Laura Muessig, *Associate Registrar*
Diane Mullin, *Assistant Curator*
Nichole Neuman, *Membership and Public Affairs Coordinator*
Linda Nyvall, *Capital Campaign Consultant*
Jason Parker, *Principal Accounts Specialist*
Judi Petkau, *Coordinator of Youth Programs*
Colleen Sheehy, *Director of Education*
Jon Shemick, *Building Operations Assistant*
John Sonderegger, *Collections Manager*
Carol Stafford, *Principal Accountant*
Jackie Starbird, *Curatorial Assistant*
Gwen Sutter, *Associate Administrator*
Tim White, *Preparator*
Shelly Willis, *Public Art on Campus Coordinator*

INTERNS

Mary Julkowski, *Public Art on Campus*
Rose Mack, *Curatorial*
Heidi Oxford, *Registration*
Barbara Pratt, *Public Art on Campus*
Kate Quinlan, *Registration*
DeAnn Thyse, *Registration*
Rachael Walker, *Registration*

STUDENT STAFF

Mandy Beardsley, *Guard*
Kelly Breth, *Public Affairs Assistant*
Colin Dickau, *Events Assistant*
Dan Elias, *Office Assistant/Store Staff*
Andy Hennlich, *Guard*
Chimeng Her, *Guard*
Paul Hydukovich, *Guard*
Alyssa Johnson, *Guard*
Sarah Jones, *Store Staff*
Reid Olson, *Custodian*
Lisa Pulley, *Events Assistant*
Cindy Quan, *Store Staff*
Carmen Regner, *Guard*
Jesse Roesler, *Guard*
Katie Sabaka, *Store Staff*
Amie Sampson, *Events Assistant*
Martha Schultz, *Store Staff*
Jessica Shain, *Store Staff*
Vincent Steininger, *Custodian*
Lena Valenty, *Store Staff*
LaMee Vang, *Store Staff*
Jason Wagner, *Guard*
Joe Waters, *Events Assistant*
Michaela Weir, *Guard*
Neil Weir, *Events Assistant*

Funding and Other Support

This project is supported in part by a grant from the National Endowment for the Arts. The B. J. O. Nordfeldt Fund for American Art at the University of Minnesota Foundation provided generous support for the exhibition and catalogue. Additional operating support for the Frederick R. Weisman Art Museum is provided by the Boss Foundation; the Dorsey and Whitney Foundation; the General Mills Foundation; HGA, Inc.; the Art and Martha Kaemmer Fund of HRK Foundation; the R. C. Lilly Foundation; Lowry Hill; Target, Marshall Field's, and Mervyn's with support from the Target Foundation; Wells Fargo Foundation Minnesota; Xcel Energy Foundation; the Minnesota State Arts Board; the Colleagues of the Frederick R. Weisman Art Museum; and the University of Minnesota.

NATIONAL
ENDOWMENT
FOR THE ARTS

Reproduction Credits